DIGITAL
photography

John Ellis

DIGITAL *photography*

Published by SILVERDALE BOOKS
An imprint of Bookmart Ltd
Registered number 2372865
Trading as Bookmart Ltd
Blaby Road
Wigston
Leicester LE18 4SE

© 2005 D&S Books Ltd

D&S Books Ltd
Kerswell,
Parkham Ash, Bideford
Devon, England
EX39 5PR

e-mail us at:- enquiries@d-sbooks.co.uk

This edition printed 2006

ISBN 10 - 1-84509-277-5
 13 - 9-781-84509-277-1

DS0096. Digital photography

Creative Director: Sarah King
Editor: Anna Southgate
Project editor: Judith Millidge
Designer: Debbie Fisher
Photographer: John Ellis

Fonts: Skia, Helvetica, Garamond, Andale Mono

Printed in Thailand

3 5 7 9 10 8 6 4

Contents

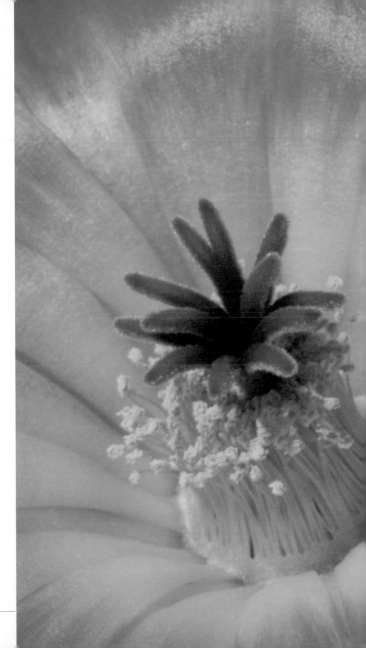

Introduction

The digital photography revolution is here, and it is here to stay. Digital photography has progressed rapidly in recent years, as computer and microchip technology have revolutionised many aspects of modern life.

Over the last few years the pace of change to digital from conventional film photography has been incredible. Eventually, it will replace it almost completely, although that will not be for several more years. If this sounds far-fetched, look at the history of colour photography: when it first arrived, colour photography was costly and black-and-white photography was the norm. As colour became more common, the demand for black-and-white pictures fell and, soon, relatively few processing laboratories offered the service, so prices soared. As the technology advances further, and the prices relating to digital photography continue to fall, it is inevitable that the transition to digital will continue.

Figure 0-01: The Canon EOS20D, an 8.2 megapixel digital SLR camera.

Figure 0-02: The Nikon Coolpix 4500 camera. Several compacts incorporate the swivel feature, which enables the lenses to be mounted in the longer dimension of the camera.

Figure 0-03: The Canon Digital IXUS i5 compact camera.

0-05a & b: The OptioX camera from Pentax. Despite having an ultra-slim aluminium alloy body, the 5.0 megapixel OptioX camera still has a 50mm, high-resolution LCD viewing screen which can be twisted round for easy viewing.

Figure 0-04: A Lexmark Z605 inkjet printer.

Advantages of digital photography

There are many advantages of digital photography over conventional photography, the most obvious of which is the sheer convenience. Because digital cameras are new technology, most incorporate many features to make picture taking as easy as possible. Even the more complicated and expensive cameras aimed at the professional market, incorporate point-and-shoot modes, as well as the options that allow experienced photographers to make adjustments manually. The settings on most cameras are accessed by means of a menu system similar to that on many mobile phones.

It is possible to examine your pictures, albeit on a small viewing screen, as soon as they have been taken. If there appears to be a problem, you can delete them and take them again. Similarly, there is no need to wait until a film is finished before downloading your images from the camera. Nor is there a delay while you send them away for processing. A picture can be taken, downloaded and e-mailed to a friend or relative on a different continent literally in a matter of minutes.

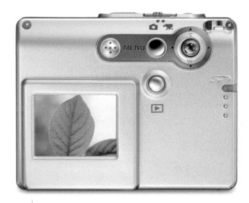

Figure 0-06a & b: The Konica Minolta Dimage X31 compact camera. The rear view shows the viewing screen typical of many digital cameras.

Running costs are almost non-existent. There is no film to buy, as the images are stored in reusable memory. The only consumables for your camera are the batteries and these are usually rechargeable. Wastage is greatly reduced: as well as the cost and ecological advantages of not using and processing films, you only print selected images. Any poor pictures can be deleted at no cost, enabling you to take more pictures, giving you a better chance of getting the shot you want. Also, you do not need to worry about airport x-ray machines fogging your pictures.

Figure 0-07: Films – not something you need to worry about with a digital camera.

Figure 0-08: Most digital cameras store images on the smaller, reusable memory cards.

In conventional photography, the entire film has the same characteristics, that is, the whole film will produce either negatives (used for printing) or positives (slides for projection); it will have a specific film speed (its sensitivity to light); and all images will be either black and white or colour. In digital photography, the memory in which your images are stored makes no distinction between negatives, positives or film speed, or even between colour and black-and-white pictures. The camera settings and/or the image manipulation software can be adjusted for each individual shot.

Unless you require something special, such as a very big enlargement, there is no need to use a laboratory for processing. You can readily print pictures using a reasonably priced printer in your own home. If you do not own a computer or cannot use one, this need not stop you, as you can print directly from cameras or memory cards. However, if you are computer literate, you can manipulate the images using computer software. This is a major benefit of digital photography for many people who use a range of software programs to make minor enhancements, to undertake major editing, or even to create new images entirely.

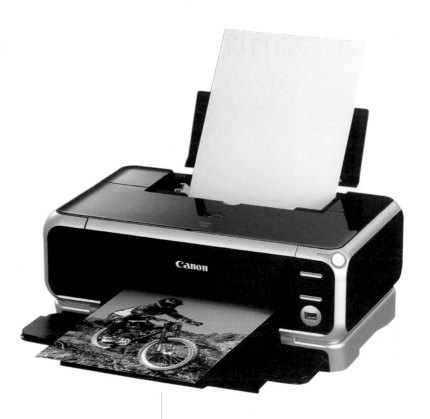

Figure 0-09: The Canon Pixma iP4000 printer incorporates a five-colour ink system and supports direct printing using PictBridge.

Disadvantages of digital photography

Despite the technological advances, there are still some disadvantages to using digital photography. To some extent the saving in running costs needs to be considered against the outlay required for equipment. The cost of cameras, memory media, printers and computers has fallen considerably, but it can still add up to a sizable sum. The initial cost of buying the reusable memory cards is quite high, and relatively few very high resolution images can be stored on them. It is therefore necessary to be able to download images onto a computer or other high-capacity storage device at regular intervals. This is unlikely to be of concern to most amateur photographers, but it is an issue if you intend to take pictures in remote locations.

Cameras, flashguns and image-storage devices all require power sources. Again, most amateurs will not find this a major problem, but it is a consideration – you would not find it easy to recharge a set of batteries in a tent on a cold mountainside!

Figure 0-10: A selection of camera batteries.

Low-resolution digital cameras cannot compete with the image quality of conventional film. However, this is not usually a problem as, for most purposes, they do not need to do so: the vast majority of images are printed at 18 x 13cm (7 x 5in) or smaller. Modern professional-quality digital cameras offer much better image quality than was possible just a few years ago. It is now only for the most extreme enlargements that there is a need to use conventional rather than digital photography.

Although many digital cameras can now be connected directly to a printer, to make best use of a digital camera , it is preferable that the photographer should have access to and be able to use a computer and suitable software.

Figure 0-11: Digital cameras are great for taking fun pictures at parties.

Why use digital photography?

Digital photography is ideal for the following:

- Creating a record of your family, children or pets. You can store images electronically without printing them, and view them on your television set via a digital versatile disk (DVD) player. Alternatively you can still make prints for a traditional album or to share with family and friends.

- Capturing images to post on a website or to send via e-mail. As printing is not required, once you have got the picture on your computer you can distribute pictures to lots of people this way at no cost.

- Taking pictures for inclusion in a newsletter, or to make into Christmas cards.

- To illustrate something you are trying to sell in a local shop window or, perhaps, on an Internet auction site.

- Taking pictures that are needed quickly – of a newsworthy event, or maybe to give to a relative or guest as a souvenir before they leave a party.

- Making a record of something such as a crime, or as evidence in a dispute.

Figure 0-12: A small digital camera that fits discreetly into your pocket or handbag is ideal for capturing shots at occasions like weddings.

This book introduces you to digital photography in a logical sequence, starting with an understanding of the basic concepts and making sense of the bewildering choice of equipment in the shops. You will then be introduced to the fundamentals of picture-taking, composition, lighting, and so on. Guidance on how to transfer the images from your camera, as well as a section on the use of scanners, will lead you onto some basic image editing using a computer. Finally you will learn about the outputs – printing and image projection. Inevitably in digital photography, terminology and jargon cannot be avoided, but a useful glossary is included for reference purposes.

Because of the pace of advancement in digital photography, any information about specific models of camera or other equipment would be out of date by the time of publication. However, the general principles described in the book will always be valid. If you are looking to purchase equipment, it is a good idea to buy a specialist digital photography magazine, which will provide you with an idea of the specifications of current models and prices.

Figure 0-13: Estate agents are among those who find digital cameras useful to help sell things.

The pros and cons of digital photography

Pros

Immediacy:
- Pictures can be checked on the camera and taken again if necessary.
- There is no need to wait until a whole film is finished before downloading the images.
- There is no delay while the film is processed.

Lower running costs:
- There is no film to buy and batteries are usually rechargeable.

Reduced wastage:
- Only selected images need be printed and the rest discarded at no cost.

Changing settings:
- The camera settings can be adjusted for each individual photograph.

Home processing:
- Pictures can be printed in the photographer's own home.
- Images can be manipulated using a home computer.

cons

Initial cost
- The cost of cameras, memory media, printers and computers has fallen considerably, but an initial outlay is still required.

Image quality
- Conventional photography gives a better image quality than low to medium-resolution digital cameras. However, the difference is not noticeable when producing small-size prints, say up to 18 x 13cm (7 x 5in) – only a professional, producing poster-size Images would have a problem with quality.

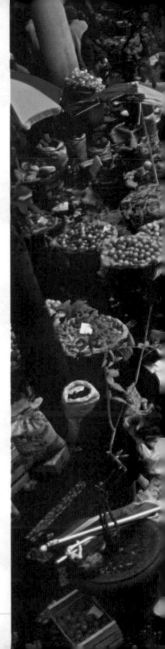

Chapter 1:

Digital Photographs

Most of us are more interested in the quality of the results than in understanding how something works. For example, do you want to know what is inside your television set, or are you just concerned that it has good picture quality, is easy to operate and that you can buy it at the right price? The same is true for the cameras, lenses, scanners, printers, computers and computer software that make up the tools of digital photography.

That said, in order to decide which camera to buy, and how to make the best use of it, it is worthwhile understanding some of the basics. It should be noted that some of the principles described in this chapter have been simplified to aid understanding.

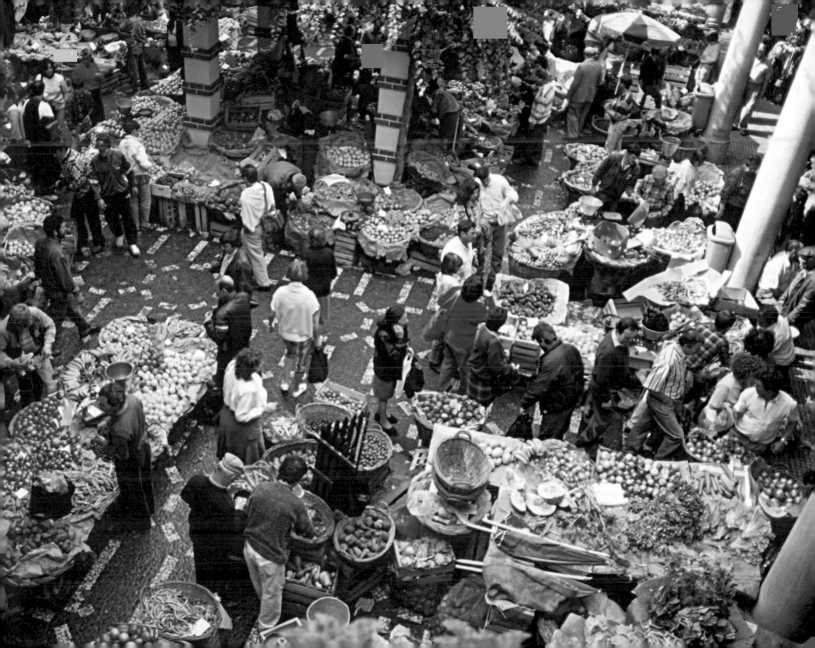

How digital photographs are made

A digital image is, essentially, a mosaic made on a grid, like a piece of squared paper. The number of squares (or in a few cameras, octagons) varies, but it is a large number, counted in millions. Each square is defined by two pieces of information: its location (similar to a grid reference on a map) and its colour. When a digital image is printed on paper, the print itself is divided into these tiny squares, each one made up of the required colour. The effect is to recreate the picture. The smaller the squares and the more accurate the definition of the colour, the better the picture will look.

Figure 1-01: The sensor array in digital cameras records the amount of red, green and blue light landing on each square. This is then converted into a digital value representing the actual colour shade of each pixel.

Using the correct terminology, each square is called a pixel (an abbreviation for picture element), and the number of pixels defines the resolution of the image. A high-resolution image has more pixels than one of low resolution. Camera specifications define the resolution in two ways. Firstly, as a number of megapixels (MP), a five-megapixel camera (5MP) can produce an image consisting of approximately five million pixels. Secondly, the grid is defined by the number of pixels from left to right across it, and the number of pixels from top to bottom (for example 2550 wide x 1950 high). If you multiply these two numbers together, you get the actual number of pixels in the image. (This will not exactly match the camera's stated MP rating which is only an approximation.)

Having defined the grid for the mosaic image, the colour and intensity of each pixel must be recorded. The higher the number of possible colours, the better the image will look, particularly in areas of subtle shading, such as skin tones.

A set of colours mixed together to create a whole range of colour shades is known as a colour model or colour space, named by the initials of the colours used. For example, RGB is a colour model comprising the three primary colours, red, green and blue. Most digital cameras – and all monitors and television screens – use RGB or sRGB (a variation of RGB).

Figure 1-02: When checking if a picture has the correct colour balance, skin tones are a useful guide.

With RGB, for every individual pixel, each primary colour is allocated a value between 0 and 255 (making 256 possible values). True red would have a red value of 255 and both the green and blue values would be 0; orange might be red = 255, green = 180 and blue = 0. White is made by adding all the colours together so all three values would be 255, similarly black has no colour components and so all three values are 0. Neutral greys are made by adding together components of identical values. The total number of colour shades that can be defined in this way is 256 x 256 x 256, giving over 16.7 million in total. This is known as TrueColour or 24 Bit colour.

It should be noted that the RGB model cannot be used for printing. Instead, printers use cyan, yellow, magenta and black inks (the CYMK colour model) to reproduce colours on paper. Under normal circumstances you should always use the RGB colour model for your images. The printer software assumes that most users will use RGB and it is designed to cater for the necessary conversion.

1-03 a & b: The RGB and CYMK colour models. As can be seen from the table opposite, the colours in the RGB model are made by adding together the primary colours in varying proportions. Other shades are created by choosing red, green and blue values between 0 and 255. This allows for over 16 million different colours to be used. The CYMK colour model works in the same way, but cyan, yellow and magenta are used to define the composition.

(a) RGB

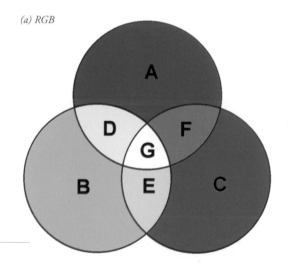

(b) CYMK

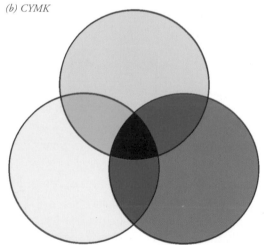

The RGB colour model (see Figure 1-03a)

Region	Colour	Composition		
		R	G	B
A	Red	255	0	0
B	Green	0	255	0
C	Blue	0	0	255
D	Yellow	255	255	0
E	Cyan	0	255	255
F	Magenta	255	0	255
G	White	255	255	255
---	Pale grey (typical)	230	230	230
---	Dark grey (typical)	20	20	20
---	Black	0	0	0

A camera has to process an amazing amount of data in order to capture each image. For example, the data file for a single photograph taken with a 5MP camera includes the individual locations of 5 million pixels and for every one it records one of 16.7 million possible colours. (Note: this is merely an illustration, not all cameras can record this many different colours in an image, others may record more. Refer to the specification of your camera for more information).

How your camera works

How your camera actually converts the incoming coloured light into the digital data file described above is of little concern to most photographers. However, a brief look at some aspects of the process is useful to help understand some apparently contradictory information you may come across when comparing cameras.

In a conventional film camera, the light enters the camera via its lens. This light is focused onto the light-sensitive film, where a chemical reaction records the image. A new piece of film is used for each photograph. Digital cameras are very similar but, instead of using pieces of film, the light is focused onto a light-sensitive sensor array, which sends the image information to the camera's memory. The same sensor array is then used to receive the next image.

In relation to the sensors, you may come across terms like charge-coupled device (CCD), complimentary metal-oxide semiconductor (CMOS), Foveon®, double honeycomb, triple-well and others. These are different technologies, all designed to achieve the same end result, but in different ways. Some use groups of four sensors to measure the red, green and blue components of each pixel, others use multi-layer technology to measure the different colours in a single location. The different technologies can affect the way that the number of pixels is counted, making comparisons more difficult than they might appear at first sight.

An important thing to consider is the relationship between the number of actual (or total) pixels and the number of effective pixels. Usually the number of effective pixels will be a few per cent lower than the total number. This is because some of the sensors around the edges of the array are not used. However, sometimes the number of effective pixels is quoted as being approximately twice the number of actual pixels. This is probably because the camera is interpolating, that is to say making an intelligent guess for some of the pixels. For example, an effective 4MP camera using interpolation will produce an image consisting of the same number of pixels as a true 4MP camera, but its sensor array will only record a similar number to a true 2MP camera. The remainder are guessed using a mathematical technique based on the adjacent pixels. Although interpolation is remarkably successful, the quality of interpolated images can never be as good as those produced without interpolation.

Figure 1-05: Fujifilm super CCD SR double honeycomb structure sensor construction. This assembly apparently provides an improved dynamic range.

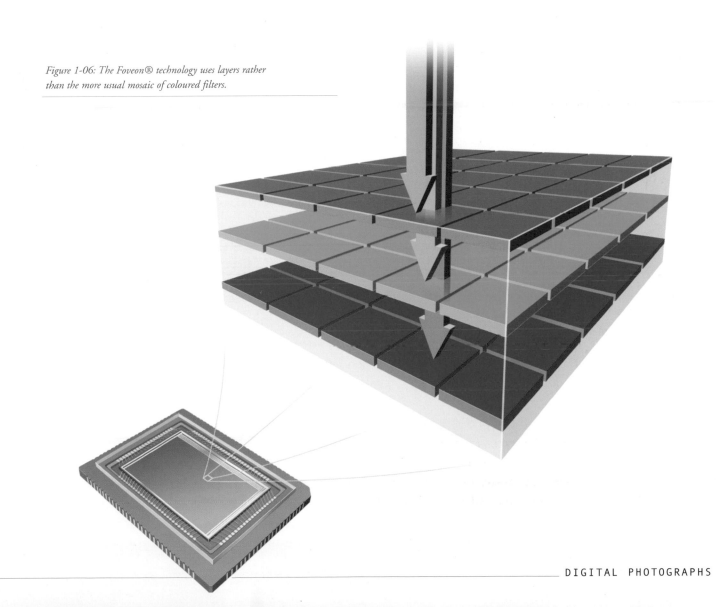

Figure 1-06: The Foveon® technology uses layers rather than the more usual mosaic of coloured filters.

Figure 1-07: High-resolution images allow for good quality reproduction, even from small objects like this dog's nose.

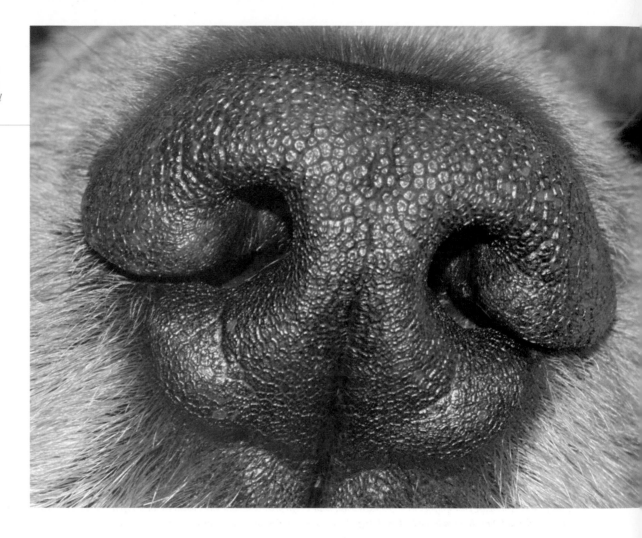

Resolution

The higher the resolution (the number of pixels), the better the image quality should be. It should be smoother and have higher definition, most noticeably in areas of fine detail. However, there are a couple of provisos worth noting in this respect.

Figure 1-08a: An image photographed at 2450 pixels wide, with a high pixel-count has nice smooth outlines. Figures 1-08 b and c show the effect of reducing the number of pixels too far: at 50 pixels (middle) and 20 pixels (right) each square pixel becomes visible and the image loses definition.

Figure 1-09: The Jessops Funcam is a very affordable low-resolution camera which stores VGA (640 x 480 pixel) images in its own internal memory.

Figure 1-10: The Fujifilm FinePix S3 Pro is a high-resolution camera with over 12 million recording pixels. It gives image sizes of up to 4256 x 2848 pixels.

Firstly, the general assumption is that the higher the resolution of the camera, the better the quality of the image it will produce. This is not necessarily true: a lower resolution image taken on a very high-quality camera with an optically good lens can be much sharper than a higher resolution image taken using a poor-quality camera.

Secondly, it is possible to re-sample the image to increase its pixel count, using image-editing software. This method will not result in an improved image, quite the opposite (see Re-sizing and re-sampling, page 176).

Figure 1-11: Large images as produced by high-resolution cameras take up lots of storage space.

In an ideal world you would always choose to buy the best equipment on the market, but that is a luxury few can afford. As a general guide for cameras of a similar type, with similar features and build quality, the higher the resolution, the more it will cost to buy. It is worthwhile looking at what resolution you actually need for what you intend to do with the images from your camera.

Consider two images: one has twice as many pixels as the other and needs to store approximately twice as much information in its data file. Assuming both images are using the same file format (see Chapter 2, page 36) the file size will be correspondingly bigger.

Larger files take up more memory in your camera, more disk space on your computer and take longer to transfer, print or e-mail. If you know that you only intend to put your pictures onto a website, or to produce small prints of your pictures, and will never want to make large enlargements, you could save money by buying a lower resolution camera. An indicative guide to the camera resolution you will require is given on page 31. It is a surprise to many people how much greater the resolution needs to be for printing than for displaying the pictures on a television screen or a computer.

When choosing a camera, you should be aware that most cameras can take pictures at several different image-size settings, so even with a high-resolution camera you can set the pixel count lower if you choose to for a specific purpose. It is also important to remember that if you want to print or display only a part of the image, the required resolution increases accordingly.

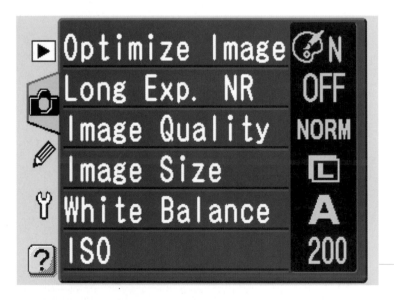

Q: What is the equivalent resolution to conventional film?

A: This is not an easy question to answer. Firstly, it depends on the size of film: most photographers use 35mm, but professionals may use larger formats for which the equivalent resolution would be much higher. Secondly, it depends on the quality – graininess – of the particular film. However, it is generally considered that the equivalent to 35mm film would be between 8 and 18MP, with most general-purpose films used by amateurs towards the lower end of that range.

Figure 1-12: Most digital cameras allow the user to set the required image size and quality from a menu screen.

Indicative guide to required resolution

The data below assumes that the full image size is being used. 300ppi (pixels per inch) is considered to be true photo quality. Refer also to Chapter 10 for information on print resolutions and an example of calculating them. It is generally advisable to use a larger resolution than the theoretical minimum.

Image usage	Image size (pixels)	Camera resolution (min)
Typical website image, or snapshot to send by e-mail	450 x 300	0.3MP
Large website image	700 x 500	0.3MP
Showing images on a television screen	720 x 5760	0.5MP
15 x 10cm (6 x 4in) print at 150ppi	900 x 600	0.5MP
Computer full-screen image	1024 x 768	1MP
18 x 13cm (7 x 5in) print at 150ppi	1050 x 750	1MP
Digital projection (SXGA)	1280 x 1024	2MP
25 x 20cm (10 x 8in) print at 150ppi	1500 x 1200	2MP
15 x 10cm (6 x 4in) print at 300ppi	1800 x 1200	3MP
30 x 25cm (12 x 10in) print at 150ppi	1800 x 1500	3MP
18 x 13cm (7 x 5in) print at 300ppi	2100 x 1500	4MP
Submission to professional image libraries	3000 x 2000	>6MP
25 x 20cm (10 x 8in) print at 300ppi	3000 x 2400	8MP

Figure 1-13: With no film to buy, digital camera users can take many more shots, ensuring they get just the composition they want.

Figure 1-14: Some conventional cameras had a panorama feature that produced pictures with a very wide aspect ratio. Although ideal for pictures like this sunset at Lake Powell, it is not necessary on digital cameras as the images can be cropped later.

Other comparisons with conventional film

As well as resolution, mentioned above, other comparisons with conventional film include aspect ratio and film speed. The aspect ratio defines the proportions of an image, and is the ratio of width to height. Conventional 35mm film frames were 3.6 x 2.4cm in size, a ratio of 3:2 (or 0.67). Some high-specification digital single lens reflex (SLR) cameras produce an image with this aspect ratio. However, the image from most compact digital cameras has an aspect ratio of 4:3 (0.75), which is the same as the standard proportions of a computer monitor. Interestingly, the European standard for paper sizes (A3, A4, A5 and so on) has an aspect ratio of 0.71, which is almost exactly halfway in between. Traditional sizes for photographic prints did not all use the same ratio: 15 x 10cm (6 x 4in) prints had a ratio of 0.67, but 25 x 20cm (10 x 8in) prints gave a ratio of 0.8. The small amount of resultant cropping of the image did not usually cause a problem.

Typical aspect ratios

Item		Aspect Ratio
Digital Camera Images	Most compacts	4:3 (0.75)
	Most SLRs	3:2 (0.67)
Computer screens and conventional televisions		4:3 (0.75)
A4 or A3 paper size		Approx. 7:5 (0.71)
35mm film frame		3:2 (0.67)
Wide-screen televisions		16:9 (0.56)

Figure 1-15: High ISO speeds help to reduce exposure times in low lighting conditions

The term film speed is a measure of the sensitivity to light of conventional photographic film. It is usually denoted by the letters ISO (an abbreviation for International Standards Organisation) followed by a number. The higher the number, the more sensitive the film. For example, to record the same image, ISO 200 film would need to be exposed to the same light intensity for twice as long as ISO 400 film. Alternatively, the ISO 200 film could be exposed to twice the light intensity for same length of time.

Many digital cameras incorporate a facility for you to adjust the sensitivity of the sensor array to mimic the effect of using a different speed film (referred to as film speed equivalent or ISO Speed). This can be reset for each individual image, making it much more versatile than in conventional photography where the speed is fixed for the entire film. Reasons for adjusting the ISO Speed are explained in detail in Chapter 4.

Chapter 2:

File Formats

As described in the previous chapter, a digital image consists of a huge grid of coloured pixels, where each pixel is defined both by its location and by its colour (see How digital photographs are made, page 18). This information can be stored in different ways, in a number of different file formats. Furthermore, some file formats can only store a limited number of different colours, while others store extra information relating to, for example, image editing.

Why the need for different formats?

Each file format has advantages and disadvantages. In order to keep the file size as small as possible, some formats are compressed, which alters the image information in some way. Some of these work by removing duplicated data. For example, where there is an area of the same colour, instead of storing both pixel location and colour for each individual pixel, the data for the colour is stored only once for the entire group. This is a lossless form of compression as the data, and hence the image quality, is not degraded.

Figure 2-01: The file size of pictures, like this one of Mallyan Spout waterfall, with few defined edges, can be reduced significantly using JPEG compression without visible loss of quality.

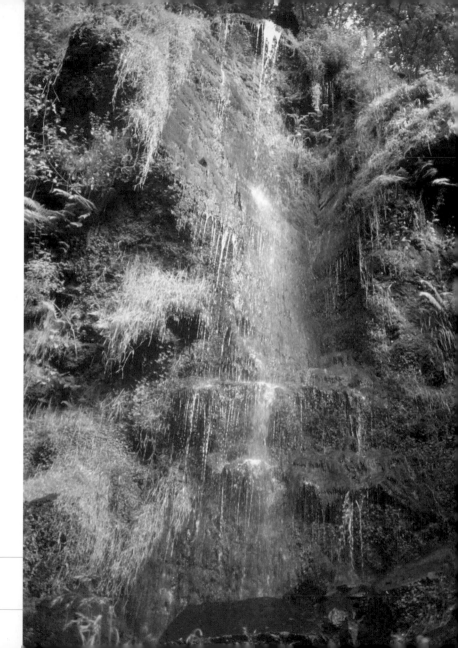

Other forms of compression – known as lossy formats – degrade the image; this loss of quality is not reversible, although the reduction in file size is normally much greater than that for lossless compression. When using a lossy format, you usually have some control over the amount of compression. It is important to note that when editing an image on your computer, every time you save the file in a lossy format it will degrade further. You would therefore be wise to select a lossless format – at least until the editing process is complete. It is worth noting that while the use of file compression software, such as WinZip, can dramatically reduce the size of some types of computer file, in general it will not significantly compress graphics files.

All computer file names incorporate an extension that informs the software of the format in which the files were created. This extension usually comprises three characters after a dot at the end of the file name: for example picture.bmp is a file called picture, which was created using the Windows Bitmap format. At one time these extensions were displayed on computers as part of the filename, but in more recent versions of Microsoft Windows the extensions are hidden from view unless you turn them on in the display options.

Although it is not practical to list all the file formats you may encounter, the more common ones include the following listed overleaf.

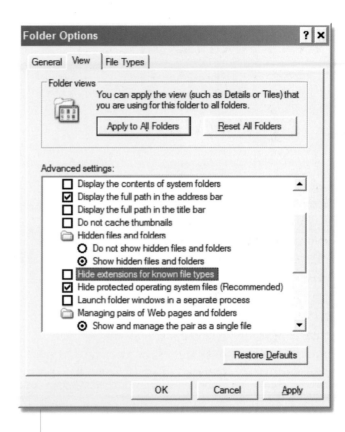

Figure 2-02: The display of file extensions can be switched on and off in Windows.

Commonly used file formats

- **JPEG (.jpg):** The Joint Photographic Experts Group format is the one most often used by digital photographers. Most cameras have the option to save images as JPEG files. It is a lossy format, but if set to best quality the degradation is very small, yet the reduction in file size is still considerable. Care should be taken using the JPEG format if there is text visible in the image, as this does tend to degrade more noticeably. Because of its good compression properties, JPEG is the standard image format for use on websites.

- **TIFF (.tif):** Tagged Image File Format files can be used in either Windows or Macintosh software. It is a lossless format and is widely used for professional photography. TIFF files tend to be large, although they can be reduced by using LZW compression. The use of this and/or other TIFF options can result in compatibility problems with some software.

- **RAW (.raw) :** RAW files are just that – unrefined or unprocessed within the camera. This is a lossless format, but the file size is generally smaller than a TIFF file of the same image. The format is an option on higher specification cameras and is used by photographers who will be processing their images on a computer. Additional data captured by the camera is also recorded. RAW image formats vary slightly from one manufacturer to the next and not all graphics software can read RAW files.

- **Camera native formats:** Nowadays all modern digital cameras offer JPEG and perhaps RAW and/or TIFF file formats. Some of the early models used manufacturer-specific formats, which are not supported by most editing software. In these cases special software supplied with the camera was required to access the images.

- **PNG (.png):** The Portable Network Graphics format is a lossless format intended for use on the Internet. It is a relatively new format and so is not supported by some software packages. It is not yet in widespread use.

- **EXIF:** The Exchangeable Image File format is used by many digital cameras to store information such as the date and time and the camera settings at the time of taking the image. Compressed EXIF images use the JPEG file format; uncompressed images use the TIFF format. The data is stored in a header and is useful because you do not need to record manually the settings you used when taking the photograph. It is very useful to help you to learn from your experiences.

- **GIF (.gif):** Graphics Interchange Format files are small in size and do not lose image definition. The downside is that they are limited to 256 colours, so subtle shading is lost. GIF files are ideally suited to clipart for the Internet – they can even support animation and transparency – but they are unsuitable for most colour digital photography.

Figure 2-03: Pictures with sharp outlines and text do not lend themselves to 'lossy' file formats, but despite that the results are not too bad. These images (1500x950 pixels) were saved as:

(a) TIFF (4,208KB)

(b) JPEG – best quality, minimal degradation.

(c) JPEG – medium compression, acceptable degradation for most purposes (115KB)

(d) JPEG – maximum compresssion, severe degradation, but a file size only 0.6% of the TIFF file (29KB)

a) TIFF format *b) JPEG format (best quality)* *c) JPEG format (medium compression)* *d) JPEG format (maximum compression)*

Figure 2-04: Limited to only 256 colours, the GIF file format is excellent for clipart but not for the subtleties of most photos.

If you need to convert between different file formats, special software packages can be purchased. However, you should be able to carry out the conversion by opening the file in your graphics editor and then choosing File – Save As, and selecting the required format.

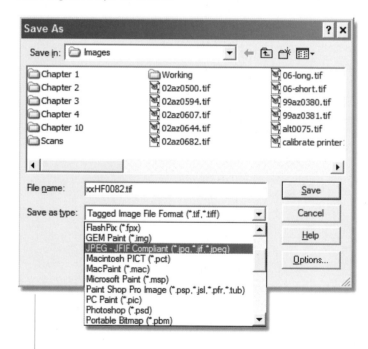

- **Bitmap (.bmp):** The Windows Bitmap format produces large uncompressed files. This format is lossless and so can be used while editing is in progress, although use of the editing software's native format would be appropriate.

- **Software native formats (occasionally referred to as proprietary formats):** Image-editing software packages can usually read (import) or create (export) files in a range of image formats – when you install the software ensure you choose all the formats you expect to use. In addition, many will save images in their own native format (Photoshop, for example, uses .psd and Paint Shop Pro uses .psp). The reason for using these formats is that they store additional information about the editing of the image, such as layers and adjustment settings (see Editing procedures, page 176) enabling additional image adjustment to be carried out at a later date. When an image is saved as, for example, a JPEG or a TIFF file this information is discarded.

Figure 2-05: A Save As dialog box, allowing the image to be saved in any of a large number of file formats

Comparison of sizes of different file formats

An image of size 3684 x 2402 in TrueColor, originally saved in Windows Bitmap format, was converted using Paint Shop Pro into various other formats. These files were then compressed using WinZip file compression software. The resultant file sizes are shown below.

File format	Size (MB)	Size using WinZip (MB)
Windows Bitmap (.bmp)	25.9	22.5
GIF (.gif) [256 colours]	5.8	5.8
JPEG (.jpg) [best quality, 1% compression]	5.4	5.4
JPEG (.jpg) [10% compression]	1.7	1.7
JPEG (.jpg) [20% compression]	1.1	1.1
JPEG (.jpg) [40% compression]	0.7	0.7
Paint Shop Pro (.psp) [single layer, no editing]	20.4	20.4
Photoshop (.psd) [single layer, no editing]	27.2	22.7
PNG (.png)	14.5	14.5
TIFF (.tif) [uncompressed]	25.9	22.5
TIFF (.tif) [with LZW compression]	18.1	17.9

Chapter 3:

Camera Equipment

A search on the Internet, or a visit to a local photographic dealership, will illustrate the enormous range of cameras available today, making it difficult to know how to choose the right one for you. The best advice is to decide the basic specification – camera type and main features – that you are looking for, then buy a copy of a specialist magazine about digital cameras. Read the up-to-date reviews and narrow your choice down to two or three specific models. Next, you should physically see and hold those cameras. You can then decide which you like best in terms of handling, weight and ease of use. It must be comfortable for you to hold steady and the controls should not be too fiddly or cumbersome.

Types of digital camera

There are several different types of digital camera. Each has advantages and disadvantages, as does each specific camera model within any particular type. The best choice for you depends on what you intend to use your camera for, and what you can afford to spend.

Figure 3-01: The extremely slim Casio EXILIM CARD EX-S100 has such compact dimensions that it can fit into a tiny handbag or a jacket pocket.

Figures 3-02: Despite its small size, Sony's Cyber-shot P150 can capture high resolution, 7.2 effective megapixel images.

Compact cameras

Small and light, self-contained, yet – for the higher specification models, at least – packed with functionality. Fully automated operation and a built-in zoom lens makes them very easy to use. The majority of digital camera users find that compact cameras do everything they need them to, and can be easily carried in a pocket or handbag. Beware of the really small models: although ideal for carrying discretely, they tend to be less easy to hold steady for taking pictures.

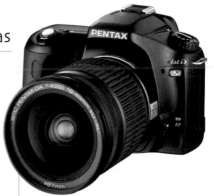

Single lens reflex (SLR) cameras

Larger, heavier and generally more expensive than compact cameras, SLRs enable the use of interchangeable lenses and other accessories. This makes them more versatile for the serious photographer, but less convenient for the more casual user. If you already have an SLR film camera,

Figure 3-03a & b: Fujifilm's FinePix E550, shown with zoom and flash extended and recharging in its cradle.

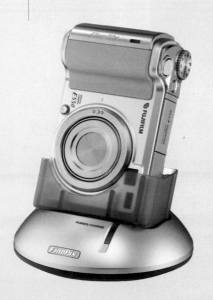

*Figures 3-04: The Pentax *ist DS, a 6.1 megapixel SLR camera.*

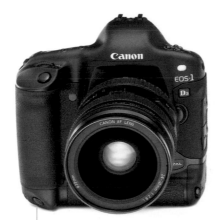

Figure 3-05: The Canon EOS1Ds, a professional SLR with a full 35mm frame-sized sensor array. The Mark II version produces 16.7 megapixel images.

you may find that you can make use of your existing lenses, an obvious consideration when selecting which model to buy. SLRs tend to use larger sensor arrays than compact cameras, giving good image resolution and quality. A few, very expensive, professional, models use the same size sensor array as the film in a conventional 35mm camera. Although many are sold with a lens, others are sold body only; you must be aware of this when buying an SLR.

SLR-type cameras

Comparable in size and weight to SLRs, but with non-interchangeable lenses, these are best described as a hybrid between a compact and an SLR. Their lenses usually have an extensive zoom range, making them useful in a wide variety of circumstances. Many of the specification features of these cameras are somewhere between those of typical SLRs and of typical compact cameras.

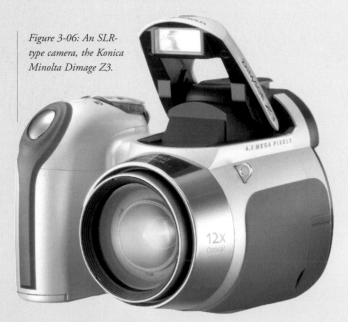

Figure 3-06: An SLR-type camera, the Konica Minolta Dimage Z3.

Figure 3-07: The Logitech QuickCam Express. Webcams are designed for quick internet transmission of small file sizes and so – in digital camera terms – have a small image size.

Webcams

Designed to send images via the Internet, webcams are generally low-resolution cameras with few features. They are designed for a purpose, and that purpose is not digital photography as described in this book.

Camcorders

Most camcorders have the ability to capture still images. Similarly, most digital cameras have a movie mode. In each case it is a feature that is of limited quality and usefulness. The use of camcorders, other than to capture moving images, is not recommended.

Figure 3-09: The Canon MVX200i camcorder has a 1.33 megapixel CCD. Camcorders will produce still images, but compared with those from digital stills cameras, they tend to be large and have low resolution.

Camera phones

Current camera phones are designed to take low-resolution snapshots to send by phone. The images are good enough for putting on a website, but much higher resolutions are needed if the images are to be printed. Functionality is also very limited – few phones, for example, incorporate a zoom lens.

Figure 3-08: The Nokia 6230i camera phone. Typically up to 1.3 megapixels, camera phones are good for pictures to be transmitted by phone or for uploading to the internet, but not for making large-sized prints.

Camera features

Some modern digital cameras have so much functionality built into them it is not feasible to describe all of the options, but here are the main features for consideration when choosing a camera. Other considerations, such as lens, battery and memory card type, are described later in this chapter.

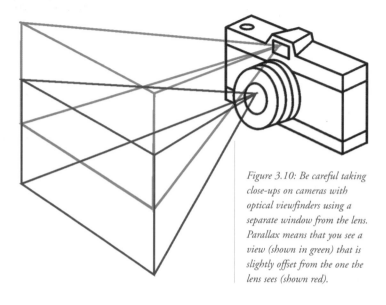

Figure 3.10: Be careful taking close-ups on cameras with optical viewfinders using a separate window from the lens. Parallax means that you see a view (shown in green) that is slightly offset from the one the lens sees (shown red).

Resolution

Ensure your camera has a high enough resolution (megapixel MP rating) to give you the quality you require (see Resolution, page 27).

Viewfinder

The viewfinder may be either optical or electronic. Optical viewfinders – where you view the actual image, rather than an electronic display of it – have the advantage that they don't require battery power so your batteries last much longer. SLR viewfinders offer through-the-lens viewing, enabling you to see exactly what the sensor will see, irrespective of what lens and or filters you may be using. The light coming through the lens is diverted into the viewfinder by a mirror. Be careful with those optical viewfinders on compact cameras that use a separate window from the lens. This can cause a problem for close-up photography where parallax causes you to see a view that is slightly offset from the one the lens sees (see figure 3-10).

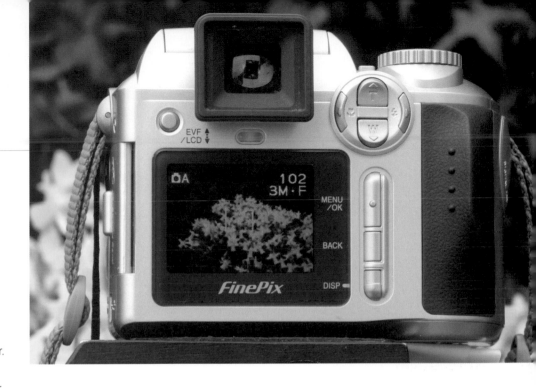

Figures 3-11: Composing a picture using the LCD viewing screen instead of the viewfinder drains batteries rapidly.

Some optical viewfinders have a dioptre adjustment that can be useful if you would otherwise need to wear spectacles when composing your photographs.

Many cameras use an electronic viewfinder. Although used like an optical viewfinder, this is a liquid crystal display (LCD), similar to, but smaller than, the camera's viewing screen. The resolution is lower than an optical viewfinder and it is not suitable for manual focusing – not an issue with compact cameras anyway. However, they do show exactly what the camera sensor is seeing as you zoom in and out, and do not suffer from the problem of parallax. They also display the camera's menu settings.

Viewing screen

This is, perhaps, the most visible difference between a digital and a film camera. In addition to the viewfinder (see above), most digital cameras incorporate an LCD viewing screen, usually mounted on the back of the camera. (Some are mounted on a separate panel that can be swung out and swivelled around). These are useful when taking photographs in awkward places – low to the ground, or over peoples' heads in a crowd, for example – where it would be difficult to get your eye to the viewfinder.

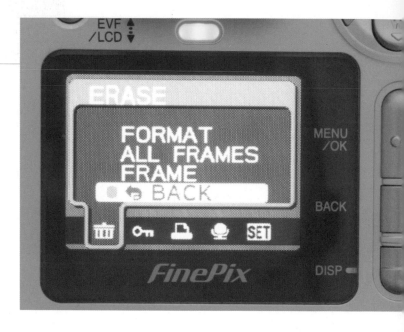

Figure 3-12: The LCD viewing screen can be used to access the camera's set-up menu.

Viewing screens fulfil three different functions. Firstly, you can use the screen to access the camera's menus in order to make changes to the various settings. Secondly, you can review images already taken: a quick check allows you to see if an image is satisfactory, or if you should take the shot again. Some cameras allow you to zoom in for a closer look at specific parts of the image. You can scroll through all the images in the memory and can delete those that are not required, freeing up storage capacity as you go along. Finally, they can often be used instead of the viewfinder when composing photographs. This is not recommended, as their use rapidly drains the power from the camera's batteries. Furthermore, the display can be difficult to read in sunlight, and holding the camera at arms length to enable the screen to be viewed makes it difficult to avoid camera shake.

ISO speed range

The wider the range of sensitivities, the more versatile the camera (see ISO speed page 83).

Shutter latency

There is a time lag between the pressing of the shutter button and the actual taking of the photograph. This delay can be a problem if you are photographing fast-moving objects. It can also spoil pictures of children or pets where the crucial moment can be lost. As a general rule, the higher the specification of the camera, the shorter the shutter latency time, but this is not always the case.

Figure 3-13: Cameras with a long shutter latency time cause difficulties when composing pictures of fast-moving objects.

Flash

Has the camera a built-in flash? if so, is it powerful enough for what you expect to be doing? If not, can you connect a separate external flash unit to the camera? External flash guns are not only more powerful than built-in units, but they are often hinged, enabling the photographer to bounce the light off nearby surfaces. Most SLR cameras will incorporate a hot shoe mount for a flash unit. The majority of compact cameras, however, lack this feature.

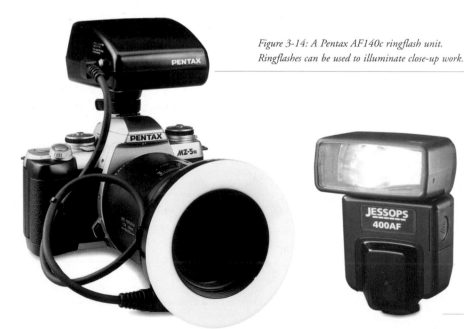

Figure 3-14: A Pentax AF140c ringflash unit. Ringflashes can be used to illuminate close-up work.

Focusing modes and depth-of-field preview

The ability to set different focusing modes helps ensure sharp pictures under difficult conditions (see Focusing pages 116).

Exposure modes, compensation and bracketing

The more exposure modes your camera has, the better it can be customised to automatically cope best with particular uses and lighting conditions (see Chapter 4, pages 80).

Figures 3-15 (left): Separate flash guns are generally more powerful than built-in ones, and enable the flash to be bounced.

Other modes

Many cameras incorporate a self-timer. Some offer facilities for continuous or time-lapse shooting (taking multiple shots one after the other, or at regular time intervals) or for multiple exposures (see pages 56 and 135). Another possible feature is a panorama mode, where one frame can be displayed as you rotate the camera, helping you frame the next in a series of shots that can later be joined using image-editing software (see Panoramas, page 200.)

Tripod mount

If you intend to do close-up work, use the self-timer regularly, or take pictures involving long exposure times, you should ensure the camera has the facility to be mounted onto a tripod.

Sound and movies

Although of limited use for most photographers, some cameras allow you to record audio comments associated with specific pictures. Others have a movie mode.

Figure 3-16: The use of a tripod helps stop camera movement spoil close-up shots.

Figure 3-17 a-g: Time-lapse was used to photograph this night flowering cactus, the camera was set to take a picture every 30 minutes over a 12 hour period. The result is a sequence showing the flower emerging from the bud.

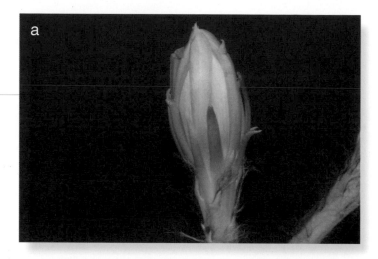

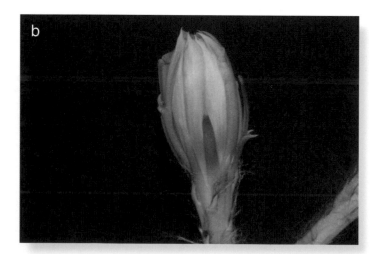

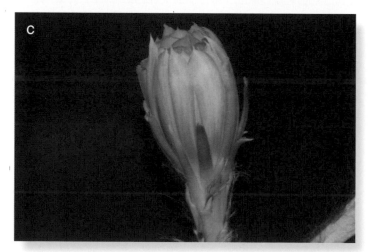

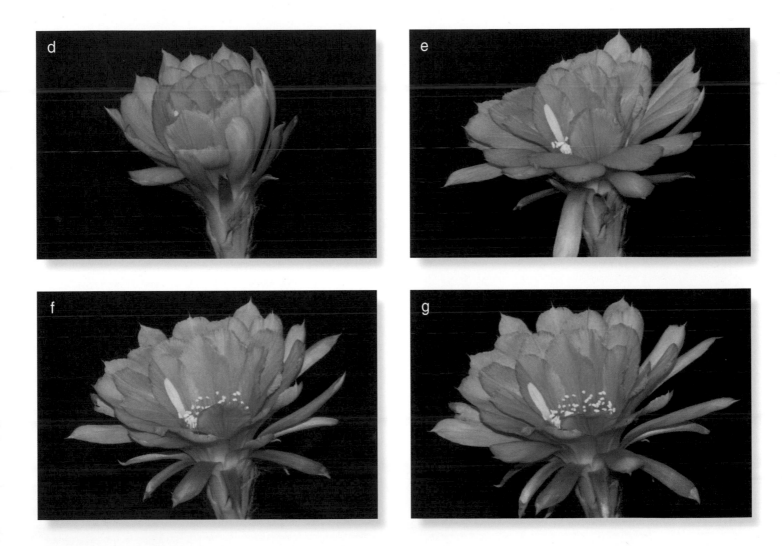

Choosing the right camera for you

Different photographers will make more use of different features and capabilities. When choosing a camera you need to consider what you expect to be photographing, and where, and what you intend to use the images for.

You can then select a camera model that will do what you need. Of course you could simply buy a camera with as many features as possible, knowing it will do everything you want – and more. This would be needlessly expensive, and you could end up with a camera that is more complicated than necessary and which would require in-depth knowledge to operate it correctly.

When you buy a new camera, unless it is a similar model to one you've used before, you may find the controls confusing and the sheer number of options and features bewildering. To begin with, set it on fully automatic then, when you become more familiar with it, start to experiment with the various controls and settings.

Whichever camera you buy, it will come with a manufacturer's instruction manual. These books can be very daunting: they are not always easy to understand and for high-specification cameras can be as long as 150 to 200 pages in total. As a result, all too often they are never read in detail. The best way to use the instruction manual is to keep returning to it over a period of months. Do not try to take it all in at once, but as you gain more experience with your camera, re-read it from time to time, and you will find you understand the information much better.

Figure 3-18: Despite the huge number of dials, knobs, buttons and switches, even the more complex digital cameras can operate on a point and shoot basis.

Figures 3-14: Not always the easiest thing to read, instruction books should be re-read as you become more familiar with your camera.

a) 18mm (29mm)

b) 50mm (80mm)

Lenses

The most common lenses are usually referred to as normal, wide-angle and telephoto. These terms refer to the angle-of-view through the lens. A normal lens is one through which the image looks roughly the same as it does to the human eye. For a 35mm film camera this would be a lens with a focal length of about 50mm. A wide-angle lens, that is a lens with a shorter focal length, enables more to be fitted into a picture, without having to move any further away from the subject. A telephoto is the opposite, it has a longer focal length – and hence a narrower angle-of-view – and makes the subject appear to be closer to the camera (see figure 3-20)

Figures 3-20a-e: These five shots were all taken without moving the camera. They show the effect of changing the focal length of the lens from 18 to 300mm (29 to 480mm, 35mm equivalent). Notice how as the focal length increases, the effect is the same as enlarging the central part of the image.

c) 70mm (110mm)

d) 150mm (240mm)

e) 300mm (480mm).

a) 18mm (29mm)

b) 50mm (80mm)

As well as changing the focal length to alter the content of a picture, you can also change perspective by moving the camera (see figure 3-21). In order to get the best composition for your pictures you need to consider both of these variables.

Figures 3-21a-e: These five shots were taken with the same focal length settings as those in figure 3-20, but this time the camera was moved to keep the road sign the same size. Notice that although the road sign is the same size, as the focal length increases, the background appears to come closer. This effect is called foreshortening.

c) 70mm (110mm)

d) 150mm (240mm)

e) 300mm (480mm).

A zoom lens is one in which focal length can be varied. This is extremely useful when composing photographs. Although in the past zoom lenses were considered inferior to fixed focal length lenses, the quality has improved to such an extent that they are now used by almost everyone.

tip

On the subject of lens quality, it is important to remember that no matter how good your camera is, and what its sensor array is capable of recording, if the lens is poor, the image quality will be poor. This is most relevant to interchangeable lenses for SLRs, but even for compact cameras it is worth reading reviews before buying to avoid getting one with poor-quality optics.

Figure 3-22: Another way to change the focal length of your lens is to mount a teleconverter between it and your camera.

Focal lengths for digital cameras

Specifications of the focal length of lenses can be confusing for digital cameras. The problem is that the size of the sensor array affects the focal length of the lens. Although this is the same for different-sized film in conventional photography, so many photographers used 35mm film that it became the reference standard used. It is quite common to see the focal length expressed in any of the following ways:

18 to 50mm.................................The true focal length of the lens.

27 to 75mm (35mm equivalent).............The focal length of an equivalent lens on a 35mm camera.

3x zoom...................................The ratio between the shortest and longest focal length, this designation is normally only used for compact cameras.

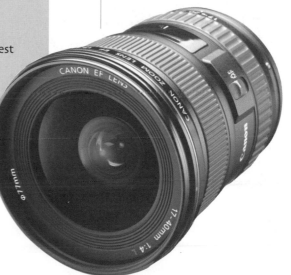

Figure 3-23: A Canon 17-40mm zoom lens. On most digital SLRs, this would be approximately the equivalent of a 26-60mm lens on a 35mm camera.

Each of the above can describe the same lens (one that has an angle-of-view of 76.5 to 31.7 degrees) although only the first one is a definitive value. Obviously the 3x zoom could describe any zoom lens with the same ratio, irrespective of its actual focal length (for example, 100 to 300mm).

Many lenses are supplied with a lens hood, in particular SLRs. If you have a lens hood, use it to help prevent stray light causing flare in your pictures.

Lenses on compact cameras

Virtually all compact cameras have built-in zoom lenses. Typically, these lenses will have focal lengths of about 35 to 105mm (35mm equivalent), although there are exceptions. Be careful when comparing the lens properties of compact cameras. Some cameras claim to have both optical and digital zooms (for example 3x optical and 5x digital). This means that the camera lens can magnify the image that is seen by the sensor array by a factor of three, the camera then crops the image and digitally enlarges the remaining part by a further factor of five, making 15x in total. This looks very impressive in the specification, but in practice it is no different to you downloading the 3x image into your editing software and cropping and scaling it up. The camera creates the image by interpolation and there is consequential loss of image quality. The only times digital zooms are of any real value are if you intend to create small size prints directly from the camera without using a computer. Some cameras have a setting to prevent the accidental use of the digital zoom, a sensible precaution if you do not want to risk poorer quality images.

The aperture range, that is, the range of available sizes of the opening in the lens through which the light passes, is quite limited on compact cameras (see Aperture setting, page 85).

Figure 3-24: The Olympus CAMEDIA C-765 Ultra Zoom. A 4-megapixel camera with a 10x optical zoom – the equivalent of 38-380mm zoom lens on a 35mm camera.

SLR camera lenses

There is a further complication with the use of the 35mm equivalent designation with respect to interchangeable SLR lenses. Because the equivalent figure is based on the difference between the size of the digital camera's sensor array and the size of a 35mm film frame, the same lens can have a different equivalent focal length if it is mounted on a different camera. In practice, other than the small number of cameras with the same-sized array as 35mm film, most SLRs have a conversion ratio of around 1.5 or 1.6. It is important to remember this if you are planning to use existing lenses on a digital SLR. You may be disappointed to find that your 28mm wide-angle is not so wide anymore in fact it would not be much wider than a normal 50mm lens on your old camera. On the other hand, a 300mm telephoto would now be the equivalent of an extremely impressive 450mm lens.

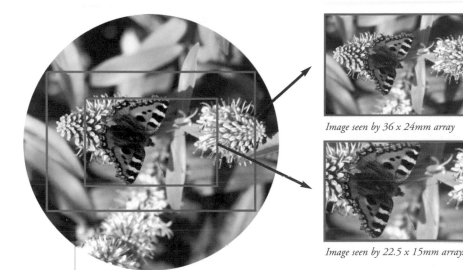

Image seen by 36 x 24mm array

Image seen by 22.5 x 15mm array.

Figure 3-25: The smaller the sensor array, the larger the effective focal length of the same lens. The blue rectangle represents a 35mm film frame or a full size sensor array in a digital SLR. The red rectangle represents the 22.5 x 15mm array that is typical of most digital SLRs and gives an effective 1.5x increase in lens focal length.

Figure 3-26: Long focal length lenses are ideal for taking pictures of birds and animals.

Figure 3-27: It is difficult to avoid camera shake with very long focal length lenses like this Canon EF 600mm (900mm 35mm equivalent). Some lenses, including the one pictured, now incorporate image stabilising technology.

There is a wide range of lenses available for SLR cameras. High-quality fixed focal length lenses, zoom lenses (including the wider angle short zooms, telephoto zooms and some that encompass both) and special purpose lenses. The latter includes macro lenses that give close-up images of exceptional quality. Camera manufacturers market their own brand of lenses, but other companies, such as Sigma and Tamron, also sell ranges of good-quality lenses with fittings to suit the various camera types. When buying a lens, take care to ensure you specify exactly which camera you want to use the lens with, not just the lens fitting – some lenses have specially designed digital versions that cater for the smaller sensor array size.

Long focal length telephoto lenses are superb for wildlife photography, or taking candid shots of people from a distance, but they do magnify any movement of the camera. Although using a faster shutter speed is advisable to minimise camera shake, this can still be a problem. Some of the new image-stabilised lens models incorporate technology that actually counteracts camera shake. They are currently very expensive, but no doubt the price will fall in years to come.

Figure 3-28: Specialist macro lenses enable extreme close-up pictures to be taken. In this case it was possible to get so close that the stamp was too large for it all to be included in the picture (it was not cropped later).

Another advantage of SLR lenses is that they have a much wider aperture range than can be found on compact cameras. Wider apertures facilitate picture taking in poor light conditions, but beware lenses with very wide apertures. There is a tendency for the image quality to suffer at the wide-open settings, and those that maintain their quality can be very expensive.

Figure 3-29: A specialist macro lens for close-up photography.

Camera memory cards

Some cameras have a small amount of built-in memory, but most rely on the use of removable memory cards. By carrying more than one card, you can increase the number of pictures you can take in a session just as you would by putting a new film in a conventional camera.

This is another area of rapid development. A couple of years ago a 128 megabyte (MB) card was very expensive and considered to have a huge capacity. Most cameras were, at the time, supplied with 16MB cards. Now, at the time of writing, 512MB and 1 gigabyte (GB) CompactFlash cards are commonplace and the launch of 8GB cards has been announced. No doubt these, too, will seem small in the not-too-distant future. Bigger-capacity cards are obviously an advantage as far as convenience is concerned, but they do have an associated risk – if anything goes wrong you could lose

Figure 3-30: Photographing garden birds takes time and patience, even with feeders to tempt them. Using a digital camera means you can take lots of shots without worrying about the cost of film.

all the pictures on the card. If you use two cards, each of half the size, you only risk losing half of your pictures.

As well as memory capacity, you should also bear in mind the data transfer speed of your card. Faster cards mean quicker download times and, more importantly, a quicker transfer time onto the card from your camera's data buffer. This means your camera will be available sooner for taking more pictures.

Unfortunately, from the photographer's point of view, there is no common standard for memory card design. If you change your camera, you may find your existing memory is not compatible with your new one, as different types of cards are not interchangeable. The most frequently seen types of memory cards for use in digital cameras are listed overleaf.

Figure 3-31: An XD memory card in the process of being loaded into a camera.

CompactFlash (CF)

CompactFlash cards incorporate memory chips and a controller.
Higher capacity cards (above 2GB) use the FAT-32 file system and
so are incompatible with some cameras. There are two types of CF
cards: Type I and the physically thicker, Type II. Cameras with slots
designed for Type II can use either, but cameras
designed for Type I cards cannot use Type II.

Secure Digital (SD) and
MultiMediaCard (MMC)

Secure Digital and MultiMedia cards look similar,
but they work in different ways, and they are not
always inter-changeable. SD cards are faster than
MMC cards and are more commonly used. SD cards of
up to 2GB are currently available. The miniSD card is
electrically and software-compatible with SD cards and can
be used in a standard SD card slot via an adaptor.

Memory Stick (MS)

The Memory Stick was developed by Sony. The
current maximum capacity is about 4GB.

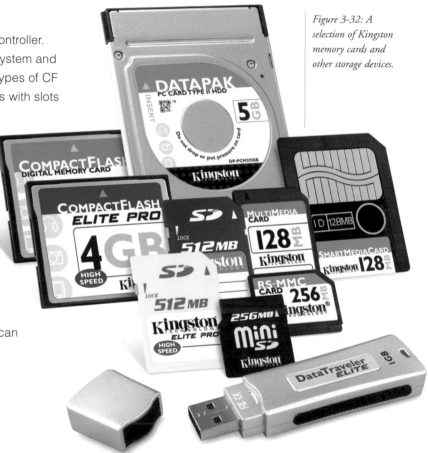

*Figure 3-32: A
selection of Kingston
memory cards and
other storage devices.*

xD-Picture card (xD)

xD-Picture cards were jointly developed by Fuji and Olympus who previously used SmartMedia cards (SM) (see below). These are very small cards about the size of a postage stamp. Currently their capacity is only up to about 512MB, but it is expected to increase.

SmartMedia (SM)

SmartMedia (SM) cards do not incorporate a controller, just memory laminated onto a plastic card. New cameras tend not to use this type of memory.

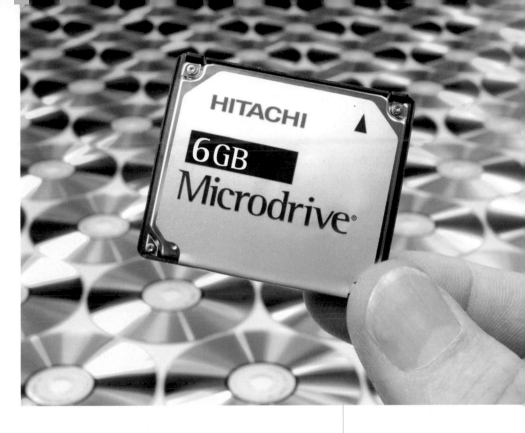

Figure 3-33: A Hitachi 6GB microdrive. It is hard to believe this small unit is like a miniature hard disk, using tiny moving parts, rather than memory chips to store data.

An alternative form of in-camera storage is the MicroDrive. These are truly miniature drives that are the same size, and are interchangeable with, CF cards. They were favoured by professionals who needed very high storage capacities, but as increased capacity memory cards are becoming available at ever-lower prices their advantage is being eroded. Because they involve tiny moving parts there are some limitations on their usage: their air-bearings do not operate correctly above an altitude of about 10,000 feet, for example (though they should work in pressurised aircraft cabins).

Batteries and power supplies

Batteries are a digital camera's only consumable item; however, they do tend to need replacing quite frequently, particularly in very cold conditions, or if the LCD viewing screen or powered zoom lens is used excessively. Thankfully, most cameras can be used with rechargeable batteries, which although more expensive initially, work out much cheaper in the longer term.

Many cameras can be used with standard AA type batteries, enabling alkaline or rechargeable ones to be used. When buying rechargeable batteries, avoid nickel-cadmium (NiCd) ones, as these can develop a memory if they are not exhausted completely before being charged up again. Nickel metal-hydride (NiMH) batteries do not have this problem, hold more charge, and can be recharged more often.

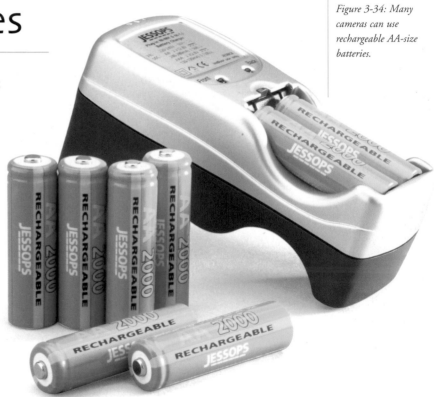

Figure 3-34: Many cameras can use rechargeable AA-size batteries.

Other cameras, particularly SLRs, require the use of special battery packs, usually lithium (Li-ion), which although expensive to buy, hold a large amount of charge. The disadvantage is that if your battery pack becomes exhausted in a place where you cannot recharge it, your camera is out of action, as you cannot make do with a set of ordinary batteries.

Battery chargers are sometimes supplied with cameras, or as optional accessories at an extra cost. Other optional accessories may include an alternating current (AC) adapter to enable the camera to be powered directly from a mains supply, or a means of attaching additional batteries to your camera. Some models come with a special cradle onto which the camera can be placed when not in use, enabling the batteries to be recharged without the need to remove them from the camera.

When choosing a camera, it is worth looking for one that has a second battery (usually a

small lithium type) which avoids losing all your settings while changing the main batteries. It is extremely frustrating – and time-consuming – having to reset the date, time and image resolution in the middle of a shoot because the battery was exhausted.

Figure 3-35: Some cameras require dedicated batteries and chargers.

Other accessories

If you are using a compact camera, you may well find that it is self-contained and you do not have a need for any additional accessories. However, there are many accessories available, particularly for use with SLR cameras. The following are the most useful (refer to your camera manual to check compatibility).

Filters

It is good practice to protect the coated surface of your lens by leaving a skylight filter permanently attached. Other filters you might consider include a polarising filter to remove reflections and saturate blue skies, or a graduated grey filter to reduce contrast between different parts of the scene.

Figure 3-36: Using a polarising filter can deepen blue skies, particularly at high altitudes where they can become almost black.

Tripod

If you are using long exposure times, or are taking close-up photographs, you need to keep the camera steady. The best way to do this is by mounting the camera on a tripod. There are many available (at varying costs) so choose carefully to suit your requirements. The heavier it is, the better the stability, but the less portable it becomes. The more adjustment there is incorporated in the tripod head, the easier it is to compose pictures. Monopods offer a less steady, but much more portable alternative, ideal for photographers who want to take landscapes, but who would benefit from the aid of a stick when walking on rough terrain.

Remote controls

If you want to trigger your camera without touching it, perhaps from some distance away, you can use a remote control. These may work via a cable, or employ an infrared or wireless signal. Some of the more expensive ones can also incorporate timer functions.

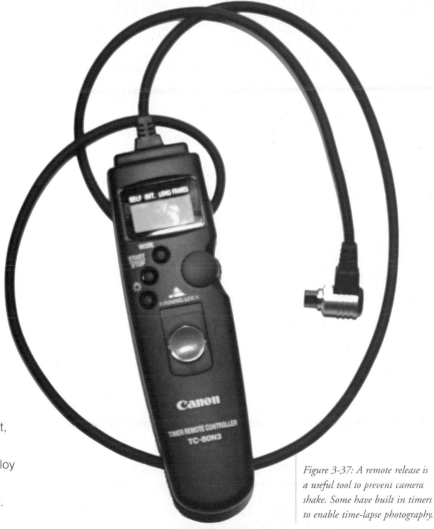

Figure 3-37: A remote release is a useful tool to prevent camera shake. Some have built in timers to enable time-lapse photography.

Viewfinder accessories

Eyepiece extenders, or right-angle viewfinders can make viewing easier under certain circumstances. The latter is particularly useful for low-level work when the camera is mounted on a tripod.

Figure 3-38: There are a few fully waterproof cameras. An alternative is a special waterproof housing, like this one made by Pentax.

Looking after your equipment

Digital cameras are precision-made pieces of hi-tech engineering, with high-quality optical lenses. There are a number of simple precautions you can take to minimise the risk of damage or malfunction. In addition to the following general advice, you are strongly advised to read the specific handling and safety instructions supplied with your equipment.

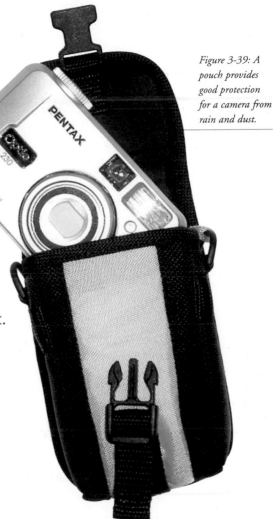

Figure 3-39: A pouch provides good protection for a camera from rain and dust.

- Take care to keep your equipment away from sand or dust. Particularly avoid allowing particles to enter your camera by opening memory card or battery compartment doors (or for changing SLR lenses) in dusty conditions.

- Always put the camera strap around your neck to avoid the risk of dropping it. Never put your camera on the car floor or in the boot without cushioning it to minimise vibration.

- Protect your camera and accessories from the elements by keeping them in a good-quality, purpose-designed case or bag.

- Do not touch electrical contacts with your fingers – doing so can cause corrosion and prevent the circuit from operating.

- Clean any dust from the camera and lens using a blower. Never use cleaning chemicals and avoid the use of compressed gas sprays. Cleaning of the internals of an SLR camera must only be carried out in accordance with the cameras instruction manual.

- Avoid exposing the equipment to strong magnetic fields, or radio transmissions (including mobile phones). These can damage the equipment and/or cause images to be erased from the memory card.

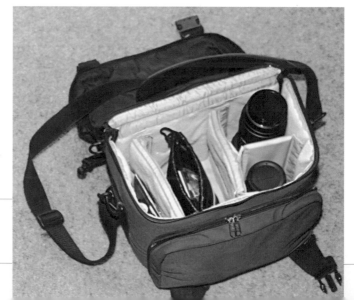

Figure 3-40: A small digital camera is easy to carry, improving the likelihood of snapping a chance action shot.

Figure 3-41: If you're planning to carry camera gear, a good quality camera bag is an essential investment.

Figure 3-42: It is important to keep your camera equipment dry.

- Unless you have bought a camera specifically designed to be waterproof, keep it as dry as possible at all times and never immerse it in water. Wipe off raindrops or splashes quickly with a soft cloth. Take care to clean off any salt splashes immediately.

- Handle memory cards carefully. Keep them clean, dry, and away from sources of static electricity or magnetism.

- Remove the battery if the camera is not going to be used for an extended period.

- Avoid extremes of temperature. In particular don't leave your equipment in direct sunlight, especially not through glass. When bringing cold equipment into a warm room, it is likely that condensation could form on it. Do not use the camera until the water has had time to evaporate. LCD displays may malfunction at very high or very low temperatures.

Chapter 4:

Lighting
and Exposure

Photography is all about light; fundamentally it is about capturing the correct colours, in the correct quantity – not too light, not too dark – to produce a record of the scene, people, or object towards which the camera is being pointed. Modern digital cameras, with their built-in light meters ensure that, in most conditions, you can achieve this with very little difficulty. Good photography goes much further, however. To turn a well-composed, correctly exposed picture into a really good one, the lighting must be right. The type of light, its colour and direction all play a part; the position and amount of shadow is important, as is the decision whether or not to use flash.

Lighting and exposure

The same principles that apply to conventional photography also apply to digital photography. However, as a digital photographer you have several advantages: you can change the camera settings between shots – you do not have to finish the film before changing it for one of a different type – and you can see your results immediately. Most people new to photography simply accept the automated settings on their camera and would never consider changing them, but as you become more interested in photography you will find that you can improve your images by making a few simple changes to some of those settings. To make the best use of light takes practice and experience, and a basic understanding of how to obtain a correct exposure is essential.

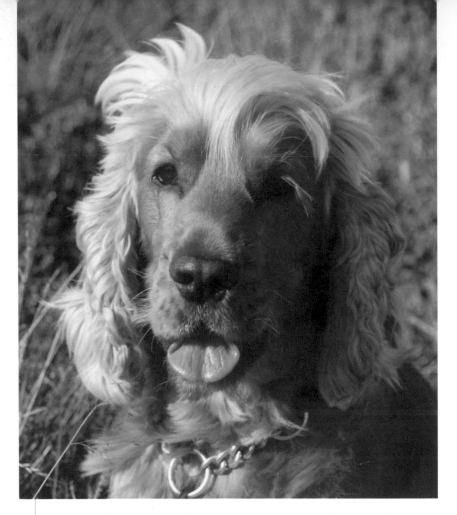

Figure 4-02: Although both dog and background are correctly exposed, this picture could have been improved if some reflected light could have been provided to reduce the intensity of the shadow.

Figures 4-03: A higher sensitivity setting allows pictures to be taken in lower light conditions, but increases the risk of noise.

ISO speed, aperture setting and shutter speed

For the exposure to be correct, there are three variables that must be balanced:

- ISO speed: This is the sensitivity to light of the sensor array. It defines the total amount of light that is required. It is sometimes referred to as the film speed equivalent.

- Aperture setting: This is the size of the opening in the lens through which the light passes. It defines the rate at which light reaches the sensor array.

- Shutter speed: This is the length of time the camera shutter is open. It defines how long light is allowed to reach the sensor array.

ISO speed

The ISO speed is defined by the letters ISO and a number (for example, ISO 400). The higher the number the more sensitive the setting of the sensor array and the less light that is needed to take the picture. The numbers work in direct proportion, so if the ISO number is doubled, only half the amount of light is required. With conventional photographic film, the most usual film speed was ISO 100, and it was most unusual for photographers to use film outside of the range ISO 25 to ISO 800. The slower the film speed, the smaller the grain structure in the film and the better the photographic definition. Although

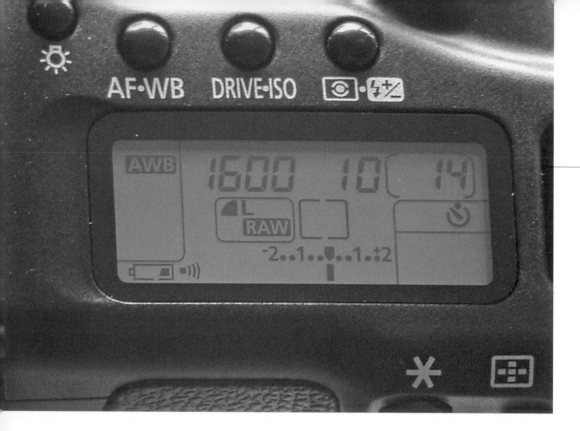

Figure 4-04: Remember to keep an eye on your camera settings. These will be displayed in the viewfinder, viewing screen and/or a special LCD panel on the camera.

there are no grain structures in digital photography, a similar situation exists. At higher sensitivities, there is a tendency for noise to become visible, that is, coloured speckles appearing in dark areas of the image. Top-of-the-range camera models often have noise reduction features to help minimise this problem. The range of available ISO speeds varies from camera to camera, but typically it would be ISO 100 to ISO 400 for compact cameras and ISO 100 to ISO 1600, or perhaps ISO 3200 for SLRs.

Aperture setting

The majority of lenses on modern cameras incorporate a mechanism that allows the aperture to be adjusted. Like the iris of your eye, which alters the size of the pupil in bright or dim lighting, it controls the amount of light passing through.

The size of the aperture is designated by a number, usually preceded by the letter f, for example f11. Consequently the expression usually used to describe the aperture is the f-stop. If the aperture is closed more, allowing less light in, it is referred to as being stopped down. The larger the number, the smaller the aperture: f11 describes a smaller opening than f4, for example. The actual range of available f-stops varies with the particular lens, but typically on an SLR camera lens you might expect to find f2.8, f4, f5.6, f8, f11, f16, f22, and possibly the very small f32. Each f-stop lets in twice as much light as the next down in size. Compact cameras tend to have a smaller range of lens apertures, perhaps f2.8 to f5.6 or similar.

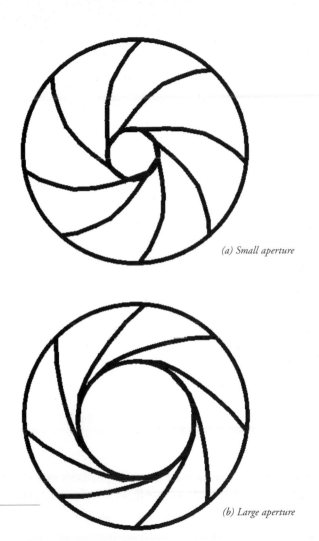

(a) Small aperture

(b) Large aperture

Figure 4-05a & b: Lenses include a mechanism to adjust the aperture: that is the size of the opening that allows light to pass into the camera.

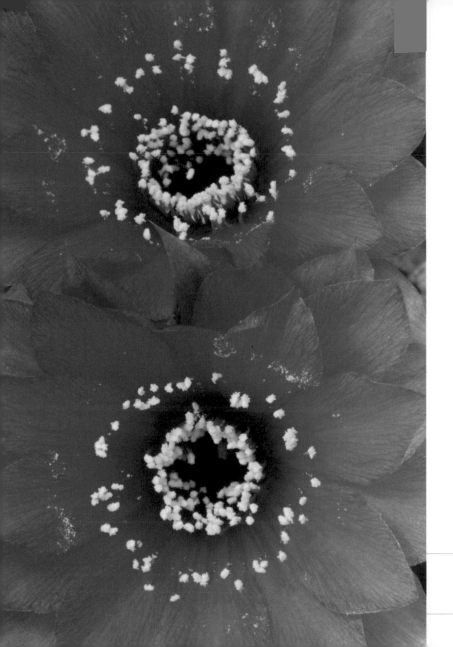

Lenses on older cameras often had a ring that was turned to set a particular aperture. Modern autoexposure cameras control the aperture automatically. Even on those models where you can change the aperture manually, this is often done via the camera's controls, rather than directly on the lens. It is worth noting that, for many zoom lenses, the maximum aperture changes as you zoom the lens. It will be at its largest when zoomed out to the widest-angle setting.

A large aperture allows more light into the camera and means that a lower ISO speed and/or shutter speed can be used. A smaller aperture has the potential advantage that objects over a greater range of distances from the camera will be in focus. This is called the depth of field and it is an important consideration, particularly for close-up work. Conversely, there are times when you might deliberately choose to set a large aperture in order to reduce the depth of field (see depth of field, page 120).

Figure 4-06: A small aperture is needed to give sufficient depth of field when taking close-ups.

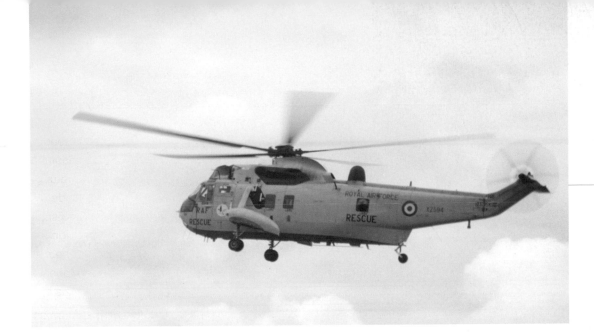

Figures 4-07: A very high shutter speed would have frozen the helicopter's rotor blades. That would have looked false, as the blurring of the blades gives the picture a sense of motion.

Shutter speed

Shutter speed is more straightforward and simply refers to the length of time the shutter is open, measured in seconds (or more usually a fraction of a second). A typical range of available shutter speeds on an SLR might be 1/3000th to 30 seconds (1/2000th to 4 seconds for a compact camera), although the majority of pictures are taken at speeds somewhere between 1/250th and 1/60th of a second. Unless you are going to use a tripod or other support, slow shutter speeds (below 1/100th of a second for ordinary shots, or below, say, 1/250th for shots using a telephoto lens) should be avoided to help prevent the risk of camera shake spoiling your pictures. If your subject is moving – a person or animal, for example – you should use a shutter speed fast enough to prevent the motion from causing blurring. Very fast shutter speeds can freeze almost any movement, but sometimes this can actually spoil a picture, making it look false. For example, an aeroplane in flight with an apparently stationary propeller (see Shooting fast-moving objects, page 132).

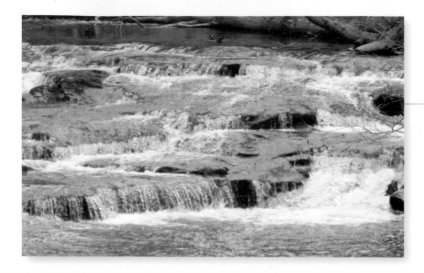

Figure 4-08a & b: A fast shutter speed of 1/500th of a second has frozen the water (top). A longer exposure of 2 seconds (bottom) gives a more pleasing effect.

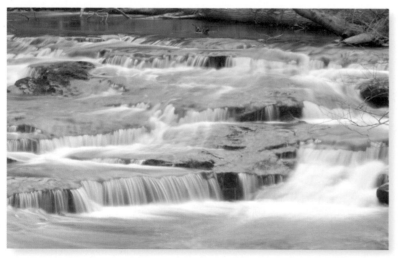

The trade-off

There is a balancing act to be made between these three variables – ISO speed, aperture setting and shutter speed. For any given lighting condition you can vary each of them but, for the picture to be exposed correctly, if you change one, then you must change at least one of the other two to compensate. When you press the shutter button to the halfway point, the current settings are usually displayed in the viewfinder and/or elsewhere on the camera.

Figure 4-09: For any given lighting conditions, the correct exposure is a trade-off obtained by balancing the ISO speed, aperture size and shutter speed. By changing settings you effectively move towards one of the points of the triangle, but in doing so you move away from at least one of the other two.

Faster speed,
freezes action and
avoids camera shake

Shutter
Speed

Slower speed,
better image quality

ISO
Speed

Aperture

Smaller aperture,
greater depth of field

If you want to reduce the risk of camera shake or the blurring of a moving subject you can increase the shutter speed (allowing light to enter for a shorter time). But in order to do so, you must then allow light to enter faster by opening the aperture (with the effect of reducing the depth of field) and/or increase the sensitivity of the sensor (ISO speed), risking a reduction in quality by increasing the amount of image noise. This is illustrated in figure 4-09.

Although this may sound very complicated, your camera can help you to choose the right setting. Most models incorporate a number of pre-programmed modes designed to allow you to choose the type of photograph you want to take. Once selected, the camera will make the appropriate settings for you. The following are typical examples of some of these modes (refer to your camera's instruction manual for specific details). In each case your camera will automatically balance the settings to give the correct exposure.

Typical camera mode settings

- Fully automatic: A general-purpose setting, where the camera controls all the variables and tries to use a middle-of-the-road approach to each of them.

- Portrait: A wide aperture is used to try to reduce the depth of field to make the background less intrusive. The ISO speed is set automatically between about ISO 100 and ISO 400.

- Landscape: The camera attempts to provide more depth to scenery and landscape shots by minimising both aperture and shutter speed. The ISO speed is set automatically between about ISO 100 and ISO 400.

- Close-up: As small an aperture as possible is used to maximise the depth of field. This will result in a slow shutter speed, but for close-up work you will probably be supporting the camera on a tripod anyway. The ISO speed is set automatically between about ISO 100 and ISO 400.

- Sports: As fast a shutter speed as possible is used to freeze the action. This will result in large aperture and a reduced depth of field. If your camera includes a multiple-shot feature (see Continuous shooting, page 135) it may automatically be activated in this mode. The ISO speed is set automatically between about ISO 100 and ISO 400.

- No flash: The same as fully automatic, except the built-in flash is prevented from operating, even in low light conditions.

- Aperture priority: You set the required aperture and ISO speed. The camera will adjust the shutter speed to suit.

- Shutter priority: You set the required shutter speed and ISO speed. The camera will adjust the aperture to suit.

Aperture priority and shutter priority are considered to be more advanced modes and they give you the most control over your camera. There may also be additional modes for Fully manual, Auto-depth of field and Night portrait, among others.

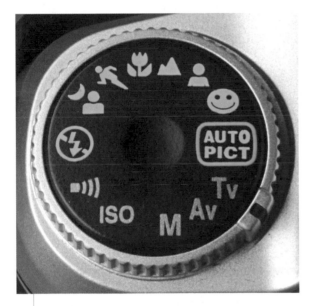

Figure 4-10: A typical dial for selecting the camera's mode.

Figure 4-11: Taking a close-up of a butterfly requires a reasonably fast shutter speed as it is likely to move, but also a small aperture to give enough depth of field

Alternative settings giving the same exposure

Even though a camera might suggest that the correct exposure will be obtained by using, say, an aperture of f8, a shutter speed of 1/250th of a second and an ISO speed (sensor array sensitivity) of ISO 200, any of the combinations listed below – and dozens of other possible permutations – will all give the same exposure.

Aperture	Shutter Speed	ISO Speed
f8	**1/250th**	**ISO 200**
f11 (half the size)	1/125th (twice as long)	ISO 200 (unchanged)
f11 (half the size)	1/250th (unchanged)	ISO 400 (twice as sensitive)
f8 (unchanged)	1/125th (twice as long)	ISO 100 (half as sensitive)
f8 (unchanged)	1/500th (half as long)	ISO 400 (twice as sensitive)
F5.6 (twice the size)	1/500th (half as long)	ISO 200 (unchanged)
F5.6 (twice the size)	1/250th (unchanged)	ISO 100 (half as sensitive)
f11 (half the size)	1/500th (half as long)	ISO 800 (four times as sensitive)

Metering

All digital cameras incorporate built-in light metering in which sensors measure the amount of light entering the camera and calculate the required camera settings, as described above. It is usual to press the camera's shutter button halfway down and then to pause before pressing it the rest of the way to fire the shutter. When the button is part-pressed, the camera will focus the lens and take the necessary meter readings in readiness for taking the picture. If you press it all the way down without pausing, there will probably be a delay before the camera shutter fires while the camera readies itself.

Under most circumstances, your camera will arrive at the correct exposure without difficulty, but not always. There are times when you will need to make corrections (see below), and there are other times when, if your camera has the necessary features, you can help it to take the necessary readings.

Figure 4-12: Care is needed with light metering for pictures of dark shapes against a bright sky. They can easily become silhouetted with loss of detail, such as the carvings on this cross.

Most photographs contain a mixture of bright areas and dark areas. If you consider these as being on a scale from very bright (white) to very dark (black), then taken over the entire picture, the average brightness would be mid-grey (indeed you can buy cards of exactly the correct colour – grey with 18% reflectance – for meter-reading purposes). In essence this is what a simple camera light meter does: it averages your picture and calculates the amount of light needed to make the average brightness a mid-grey. Many digital cameras employ an adaptation of this method, where the readings are biased to give the central part of the picture more importance. This is known as centre-weighted metering.

You may come across the expression matrix-metering, an evaluative form of metering where the entire image is divided into zones. The camera balances the readings from each zone, taking foreground and background areas into consideration. In addition the very outer edge regions and/or extreme light and dark readings may be disregarded completely. This sophisticated system provides very accurate readings in a wide variety of lighting conditions.

Figure 4-13: A special grey card can be purchased to assist with metering in difficult lighting conditions.

A further option on some cameras is partial or spot metering. This is an extreme form of centre-weighted metering, where the reading is taken from only a very small region, perhaps 5 to 10 percent of the picture area. The area is usually in the centre of the image, but some cameras allow the user to choose its location. This method is useful if the image contains some extreme conditions of light or dark that would, if included, bias the readings and result in an incorrect exposure for the main subject of the picture.

Figure 4-14: Bright sunshine on a snowy landscape can confuse your camera's light meter and cause your pictures to be under-exposed.

Making corrections

Despite advances in the accuracy of built-in metering systems, there are still occasions when they may not give the result you want. Examples of when this might occur include a deliberate silhouette, a sunrise or sunset, a very bright snow scene, or maybe a picture of a relatively dark object against a very bright sky – at an air display perhaps. As previously mentioned, one advantage of digital photography is that you can see your results without having to wait to get your film processed. In many cases if you are unhappy with the images you can take them again straight away, but not always – the moment might be lost – so it is always wise to be prepared for a possible problem if lighting conditions are unusual.

Exposure compensation

If you have taken a picture and are unhappy with the result
(the image should have been lighter or darker), or if your
previous experience leads you to anticipate such a problem,
most cameras allow you to set an exposure compensation
value. That is, the camera will take its light meter reading and
then deliberately decrease or increase the settings to under- or
over-expose the image. How you set the camera to do this,
and the amount of available compensation, varies from camera
to camera. Typically you will be able to set the camera to use a
setting up to two or sometimes three stops each side of the
theoretical exposure setting in increments of 1/2 or 1/3 of a
stop. Check your camera's specification to see what it is
designed to do. Up to two stops of compensation in half-stop
increments would typically be denoted as +/-2EV in 0.5EV
steps. The letters EV stand for exposure value.

To a large extent exposure compensation involves trial and
error, or at best an educated guess based on previous
experience. Increasing the exposure makes the image brighter,
so if your picture of a sunny, snow-covered landscape looks
dull and grey, try increasing the exposure by one or two stops.

Figure 4-15a & b: White flowers are particularly difficult to photograph. The image on the left is too dark because the amount of white confused the camera's light meter. The image on the right was taken with an exposure correction of +1EV.

Bracketing

Some cameras include a bracketing feature. This can be set to enable the camera to take multiple shots of the same image, one at the calculated exposure, the rest incorporating various amounts of exposure compensation. In addition to ensuring you get a correctly exposed image, it is a useful way of learning to anticipate required exposure corrections in particular types of lighting conditions. After a while you may well find you can set the correct exposure compensation factor yourself without the need for bracketing.

When you've finished using exposure compensation or bracketing, always remember to reset your camera ready for taking pictures in normal lighting conditions again.

Figure 4-16: It is not always practical to use a tripod for street scenes. However, some lack of sharpness can usually be tolerated for this type of picture. Dark areas of shots like this are prone to coloured speckling known as noise.

Taking pictures in low light conditions

Figure 4-17: Industrial landscapes can provide good subjects for night photography.

If the light is poor, one option is to use flash (see pages 103) but there are alternatives. For indoor work, you could use artificial lighting. Professional studio lighting can be expensive, but particularly with the ability of digital cameras to correct the white balance (see page 109) you can make use of other artificial light sources.

For outdoor photography, where the range of your flash is often insufficient, you can use fast ISO speeds and very long exposures to take pictures in surprisingly dark conditions. There are many possibilities for after-dark pictures, perhaps the most obvious include floodlit architecture and street scenes, but there are others – you might try industrial scenes, lights reflected on water, or fireworks for example.

The same principles apply to indoor photography where flash is not permitted, or where the room is too large for flash to be effective. Before you begin, set the ISO speed in your camera's menu to a high setting. You will need to experiment to find the highest speed your camera can use before noise becomes a problem in the darker areas of your pictures. Also, make sure your built-in flash is set to off so that it does not keep popping-up because of the low light meter readings.

Despite using a high ISO speed and a large aperture, you will find that you will need to use long exposure times (slow shutter speed settings, typically in the range 1 to 30 seconds). Your camera will calculate these for you, but because of the generally dark scene, perhaps containing extremely bright, localised light sources (lamp posts, for example), you may

Figure 4-18: The inclusion of some buildings or other feature can add to the effectiveness of fireworks.

Figure 4-19: Although the helicopter was stationary, it – and the lights on buildings behind it – are not sharp because it was impossible to hold the camera steady without a tripod.

need to use exposure compensation or bracketing. Again, the advantage of digital photography is that you can experiment with settings without wasting film and you can see the results while you are still able to take the pictures again if necessary.

In particularly dark conditions and for photographing fireworks, use your camera's manual mode (if it has one) and set the shutter speed to bulb. In this mode the shutter opens when you press the shutter button and remains open until you release it. If you choose a fairly small aperture you can then leave the shutter open for a minute or more – there is a lot of trial and error with this approach, but it can be fun and you can get some interesting results.

Movement with long exposures

Because of the long exposure times, it will be virtually impossible for you to hold the camera steady. Ideally, you should use a tripod, but it is possible to improvise effectively. If there is one, you can rest the camera on a conveniently located wall or post. A small bean bag is useful for this as it keeps the camera clean and dry, helps it to sit snugly without wobbling, and raises it up slightly. At the absolute minimum, if nothing else is available, support the camera in both your hands and use your elbows as supports to steady it.

Figure 4-20: The bright light towards the top right of this picture draws the eye too much. It would have been even worse if it had not been carefully placed behind a mast to reduce its effect.

Even with the camera held steady, you must accept that there may be movement in your picture. People may move, they may even walk into or out of your shot, and if there are any roads in the scene cars may pass by. You can only look at your picture and decide if the movement is acceptable – if not, try again. If the exposure time is long enough, it is possible that a fast-moving dark object – say a person running through your scene may not be visible at all in the photograph. The lights of moving vehicles will make red and white trails, an effect which can look awful in some scenes, yet can be really successful in others. Although often unavoidable, and sometimes beneficial, in general, try not to include bright points of light in the foreground of your picture. As well as confusing the exposure reading, they tend to enlarge to a pale blob that spoils the picture.

Figure 4-21: It is amusing watching a Grand Canyon sunset and seeing the flashguns firing off from the rim. They certainly won't illuminate the canyon, which is up to 18 miles wide and 1 mile deep!

Using flash

Many people assume that if the light is poor then you must use flash. Indeed some of the more basic cameras make the same assumption, forcing its use even when it is not appropriate. That said, the correct use of flash is a very valuable technique, made easier by the fact that virtually all digital cameras incorporate a built-in flash facility.

When not to use flash

Flashguns, even powerful ones, have a fairly limited range. Those built into cameras usually have a maximum range of only a few metres, extended slightly if your camera has a good range of ISO speed settings. There is, therefore, no point trying to use flash for landscape shots, pictures of large buildings, or from the back of a stand at a sporting event. It is also important to remember that flash photography is not allowed in certain places. Museums and art galleries in particular do not allow flash photography – and some do not allow any photography for security reasons – as it would eventually cause the exhibits to deteriorate. Some establishments do not allow flash when it might disturb other visitors, while others – where there are fast-moving performers, for example – prohibit it for safety reasons.

Cameras with built-in flash units are extremely convenient and are excellent for lighting up snapshots of small groups of people, for fill-in flash, and so on. The disadvantage here is that they can only be used for direct flash (where the flash is on the camera and is pointing straight at the subject). The problem with this is that there will often be harsh shadows behind the subject and the pictures will have little depth to them. Any glass or other reflective surface behind your subject will catch the

Figure 4-22: Beware of using flash near shiny surfaces – part of the picture is hidden by the flash reflecting from the glass in the frame.

light and this can spoil your picture. Finally, everyone has seen pictures of people with evil-looking red eyes. This red-eye effect is the result of the flash reflecting back from the subject's eyes. Many cameras now incorporate a red-eye reduction feature. This works by either a lamp or the flash itself, illuminating briefly just before the photograph is taken. The light causes the iris of the eye to close partially, which in turn reduces the reflection of the flash. It is a useful feature, but is not 100 percent effective. Red-eye can be removed very effectively from digital images using image-editing software (see Red-eye removal, page 186).

Figure 4-23: A hot shoe mounting for an external flash unit.

Alternative to built-in flash

If your camera supports their use, you can use a separate flashgun. Some digital cameras, particularly SLRs, incorporate a hot shoe (a mounting bracket, with electrical contacts to enable the camera to communicate with a flashgun) onto which the flash can be mounted. Although this is still on the camera, most flashgun heads can be tilted, so for indoor work the flash can be bounced off a low ceiling. This reduces the effective range of the flash (the light travels further and some is lost when it is reflected off the ceiling), but it softens the light, and avoids both red-eye and the harsh shadows behind the subject. The reduced range is not normally an issue, as freestanding flashguns tend to be considerably more powerful than those that are built into camera bodies. Beware of coloured ceilings, as these can affect the colour of the flash.

Figure 4-24 a & b: The view out from the church porch is correctly exposed, but the brighter light outside makes the stonework very dark. A longer exposure would have lightened the porch, but the view outside would have been over-exposed. The second shot (right) uses fill-in flash to illuminate the walls, while leaving the scene outside correctly exposed.

Figure 4-25: Some flash guns can be set to fire multiple flashes, creating an interesting effect with moving objects.

Although many digital compact cameras do not have a hot-shoe mounting, a few do have a PC flash sync terminal via which an external flash can be triggered. This makes holding the camera and flash a little difficult, but it has the additional advantage of enabling the flash to be held away from the camera.

You should not limit your use of flash to pictures being taken in the dark. Even in bright daylight it can greatly improve your pictures. The technique is called fill-in flash and it is used to remove deep shadows and to light up detail on subjects that are back-lit. For the latter, the images are also often improved by the reduced exposure necessary to light the subject, helping to prevent the brighter background from becoming over-exposed and washed-out.

If you enjoy flash photography and find yourself wanting to experiment further, you might consider trying to use more than one flashgun. A cheap slave unit will use the flash on your camera to trigger one or more other flashguns located at different angles to the subject. Other possibilities include the use of coloured special-effect filters, or even a strobe unit to freeze a moving object in several positions.

Figure 4-26 a & b: The Bird Cage Theatre in Tombstone, Arizona, dates back to 1880. Although the flash has illuminated it successfully (top), the long exposure (bottom) gives the room a more authentic feel.

Figure 4-27: Artificial light tends to give photographs a strong colour cast.

White balance

Artificial light sources tend to be a different colour from daylight; the light from a normal tungsten light bulb, for example, is very yellow compared with sunlight. Other light sources are different again, – fluorescent lights tend to be slightly green, for example. Even daylight varies depending upon the amount of cloud, shade, or the the time of day. Another example is a covering of snow on a sunny day, which will often appear blue. Because the effect is most noticeable on white objects, the phenomenon is referred to as the image's white balance.

The different colours of the various light sources are referred to as the colour temperature and are defined using degrees Kelvin (K). For example, tungsten electric light has a colour temperature of about 3200K. Be careful with terminology here: the human brain associates bluish colours with cold (ice and snow) and reddish colours with heat (fire), and so although blue light has a higher colour temperature, it is usually referred to as being cooler than the warmer red light with a lower colour temperature!

Your brain automatically compensates for this phenomenon and so you tend not to notice the effect unless it is very pronounced, perhaps at dawn and dusk when the sun is very low. However, different lighting conditions give a colour cast that is very visible in conventional photographs. So much so, that photographers often use coloured filters or buy special film to try to correct the effect.

Thankfully, all but the most basic digital cameras enable the problem to be solved rather more easily. Many incorporate an automatic white balance correction feature: you ignore the issue and the camera will make the necessary adjustment on its own. Like most automated processes, however, it is not 100 percent successful. More advanced cameras offer additional pre-defined settings, including the following:

- Daylight (around midday, early morning and evening light is redder)
- Cloudy
- Artificial – fluorescent
- Artificial – tungsten
- Electronic flash

Most advanced of all, some cameras include a manual custom setting, which allows you either to set the colour temperature or to photograph a true white and use that as the baseline for the camera to apply a correction to subsequent images. Some cameras incorporate a white balance bracketing feature that enables them to take several shots of the same image at various colour temperature settings.

An alternative approach is to take the photograph first, and then you can apply a white balance correction later, using image-editing software on a computer. You can do so by manually adjusting the image colours until they look correct, or with some software you can nominate a location in the picture that ought to be true white and the software then applies a corresponding correction to the colour balance of the whole image.

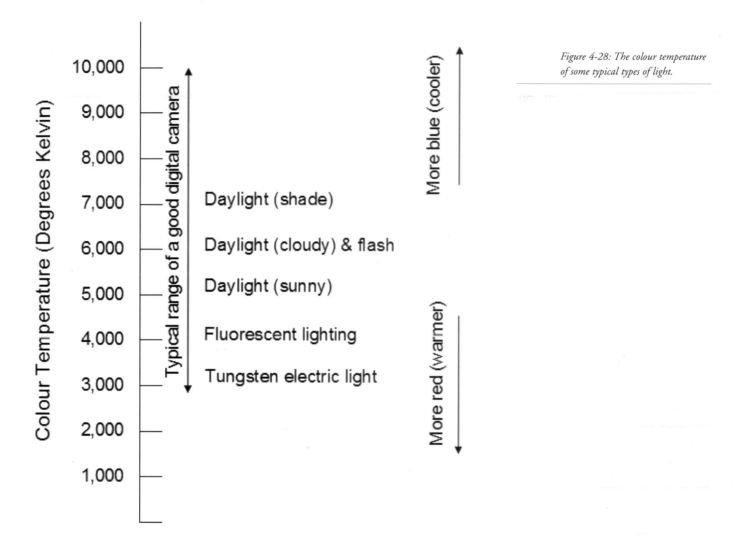

Figure 4-28: The colour temperature of some typical types of light.

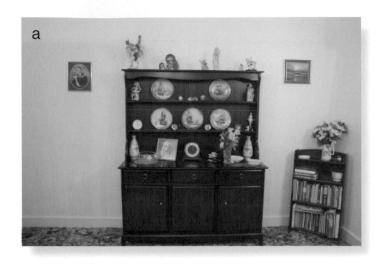

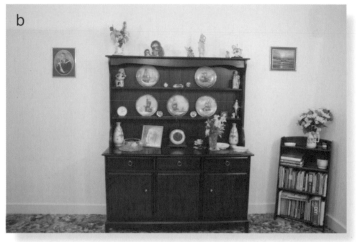

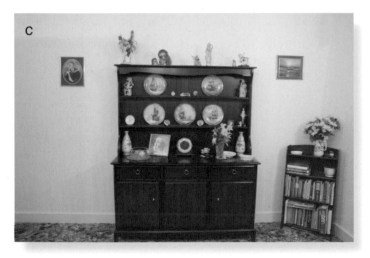

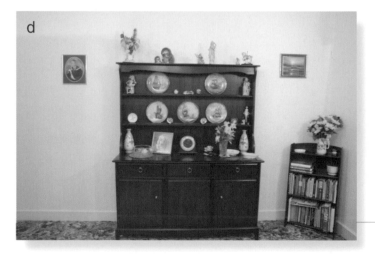

Figure 4-30 (right): Detail can be difficult to see in the dark areas of pictures with lots of contrast

Figures 4-29 a-d: Although the walls of this room were painted white, they can appear quite yellow when photographed lit only by the room's electric light. This effect can be corrected using the digital camera's white balance control:

a) White balance set to 'daylight' – a very pronounced colour cast.

b) White balance set to 'auto' – a reduced, but still very noticeable colour cast.

c) White balance set to 'tungsten' – improved, but still a slight colour cast.

d) White balance customised to suit the actual lighting – the walls are now the correct colour.

Contrast

Contrast is the difference between the dark and light regions of an image. A picture with too high a contrast range could look stark and lose detail in shadows or bright areas. Conversely, low contrast can give flat and boring images. Some cameras offer a range of contrast settings. Although you will probably find the normal setting is fine for most of your needs, you should be aware that you can adjust the contrast on the few occasions when it would enhance your pictures. Contrast can also be adjusted later using image-editing software (see Adjusting brightness, contrast and colour, page 188), but the better the image taken by the camera and the less need for subsequent adjustment, the better quality it will be.

Chapter 5:

Picture Composition

Every photographer has his or her own preferences and specialities when it comes to choosing what to photograph. Many people are happy just taking holiday pictures and shots for the family album. Others enjoy photographing landscapes, buildings, plants and flowers, people, pets or sporting events. Each different subject requires slightly different techniques, but all employ many of the same fundamental principles. With a good basic grasp of the skills of picture composition you will be able to try your hand at most types of photography.

Figure 5-01: Most photographers take pictures of a variety of subjects, but some concentrate their efforts in specialist fields, like close-ups of plants.

Focusing

Apart from the occasional use of blurring to show motion, or for some particular creative effect, the subject of your photographs should be as sharp as possible. Out-of-focus images, like any other unwanted pictures, should be deleted.

Old camera lenses had to be focused manually by turning a ring on the outside of the lens until the image in the viewfinder became clear. Despite the use of various focusing screens to help with this, many people found it difficult to know when the correct focus had been attained.

Figure 5-02: Billowing smoke, clouds or shimmering water can all cause problems for autofocus systems.

Modern autofocus cameras are designed to set the correct focus automatically. They may either focus on a single point or take readings from several points within the image. These systems work very well under most normal conditions, but there are times when they may be unsuccessful. A scene with little contrast, for example, or one that is inherently fuzzy, say with shimmering water or billowing smoke. In addition, some cameras have difficulty in low light conditions, while some are better than others at coping with moving objects. The best cameras have built-in software that can track an object moving at a uniform speed and so can actually anticipate the required focus at the time of the shutter firing.

If the camera is unable to get a focus lock it will display a warning to that effect in the viewfinder. Depending on the model you have, you may be able to use a focus lock feature to set the focus. This is done by pointing the camera at an object the same distance away as your subject, then locking the focus (see your camera handbook for how to do this). With the focus locked, you can recompose the image and fire the shutter. The same technique is useful if your camera has chosen to focus on the wrong part of your picture, such as something in the background.

The more sophisticated cameras incorporate a choice of focusing modes, depending upon your composition. You may also be able to select a point in the viewfinder – other than the usual centre spot – as the basis of the focus setting. Some cameras, particularly SLRs, still have the facility for you to switch to manual focus. This can be very useful for special work, such as extreme close-ups, where focusing is critical, or when the conditions prevent the autofocus from operating correctly.

Figure 5-03: This picture, supposedly of the wooden toucan, is spoilt because the camera has focused on the wrong thing – the garden behind is sharp, instead of the carving.

Troubleshooting un-sharp images

Blurred pictures can be caused by any one of several possible reasons. The most likely causes, and how to remedy them, are described below

Description of problem	Likely cause/remedy
Your main subject is sharp but the background and/or foreground are not.	Insufficient depth of field. Use a smaller aperture setting.
Although your main subject is not sharp, other parts of the image are.	Camera improperly focused. Check autofocus warning is not displayed in viewfinder. Try using focus lock or focus manually.
Nothing in your image is sharp.	Camera improperly focused. Check autofocus warning is not displayed in viewfinder. Try using focus lock or focus manually.
The image is blurred, none of it is sharp, dots appear as lines.	The camera moved during the exposure. Mount the camera on a tripod, or some other support and/or increase shutter speed.
Your main subject is blurred, but the rest of the picture is sharp.	The subject moved. Use a faster shutter speed.

Depth of field

Although the main subject of your picture should be as sharp as possible, it does not necessarily follow that everything in the shot should be in focus.

The setting of the lens aperture affects just how much will be in focus. A small aperture means that objects over a greater range of distances from the camera (the depth of field) will be in focus. You may deliberately choose a shallow depth of field in order to cause a potentially distracting background to become blurred, ensuring the viewer's attention is drawn to the subject of your picture. Alternatively, if you are taking a close-up shot you may need to use the smallest possible aperture to ensure the whole of your subject is in sharp focus. Similarly, if your landscape shot includes a foreground feature, you need to ensure that both it and the main scene behind are in focus.

Some SLR cameras have a depth of field preview facility. This allows you to view the image with the aperture stopped down. The image is very dark and it is not easy to see, but it does show you exactly what will be in focus in the photograph. Normally when you look through the camera's viewfinder, you are looking at the image with the lens aperture wide open, which allows the maximum passage of light for you to see the image as clearly as possible. When the shutter button is pressed, the camera reverts to the preselected aperture to take the picture.

As well as aperture size, the depth of field is affected by another factor, although it is not a variable, as it is not something that you can change. Depth of field is proportional to the size of the image in your camera, that is the film size or, in digital cameras, the size of the sensor array. The smaller the sensor array the greater the depth of field in your image, and hence the less scope you have deliberately to reduce it – for example, to blur a background. The scope for controlling the depth of field is further limited on those cameras that only offer a small range of aperture settings.

Figures 5-04 a&b: The difference in depth of field between these two images is pronounced. The image on the left was taken using a large aperture (f2.8) and only a couple of centimetres are in sharp focus. The one on the right was taken using a very small aperture (f32) and it is almost all in focus.

The focal length of the lens also appears to alter the depth of field, but this is not actually the case – it is an effect caused by the fact that images appear further away in wider-angle lenses.

For example, if you were photographing a statue and moved your position back from it so that it was the same size in the frame with a normal lens, the depth of field would in fact be identical.

Composition guidelines

Despite the widespread use of the expression 'rules of composition', in reality there is only one rule: it is your picture and you are free to conform to, or go against, the advice of others.

Figure 5-05: Filling the frame completely adds even more impact to this picture of a huge American truck.

The so-called rules are merely guidelines, suggestions that derive from the collective experience of generations of photographers. These guidelines contain excellent advice and if followed will, without doubt, improve your picture composition. However, do not feel that they must always be followed for every picture. Every shot is unique and, as the photographer, it is you that must choose what you want it to look like. It is interesting to see the results from a party of experienced photographers taking pictures in the same place at the same time. There is always a great variety of composition depending upon the photographers' individual styles and preferences. You must remember also that the people viewing your photographs will have their own personal preferences.

Orientation

Remember that you can rotate your camera through 90 degrees to make the picture taller than it is wide. This is known as portrait format, as opposed to the more frequently used landscape format, where the image is wider than it is tall. The two names are derived from the fact that most landscapes require a wide picture, but images of people, particularly shots of the head and shoulders, are better suited to the taller format. If you are photographing scenery, don't feel obliged always to use the landscape format, but use what best suits the particular view.

When choosing the orientation, also bear in mind your intended use for the image. For example, if you want a picture for the cover of a newsletter you may have to use a portrait format so that the picture can be printed the correct way up. Conversely, if you always intend to show your pictures using a television set, landscape format fills the screen and looks better.

Figure 5-06: Remember to consider both landscape and portrait formats when composing your pictures.

Shape

Related to its orientation is the shape of your image. As an alternative to the usual 3:2 or 4:3 aspect ratio, your subject might be better suited to a square or a widescreen panoramic format. Some cameras have a panoramic setting, but most digital cameras do not. The feature is no longer necessary, as you can crop the digital image to whatever shape you want using image-editing software (see cropping, page 180). You can even choose to make heart or star shaped pictures, though such shapes should be used sparingly or their impact is lost. Most cropping is merely the tidying up of your images, but if you know you are planning to crop a specific image, you should bear that in mind when taking the picture to ensure the crop can be achieved without the loss of any of the intended subject matter.

Thirds

Probably the most frequently quoted rule of composition is the use of thirds. Imagine your picture being divided equally into nine rectangles, three across by three up. The main features of your image should be placed not in the

Figure 5-07: The occasional use of shape can be effective, but don't overdo it!

centre of the frame, but on these dividing lines. For example the horizon would go on one of the horizontal lines, or a tree trunk would go on a vertical one. Ideally the subject of the picture should be located on the intersection between two of these thirds, (see figure 5-09). The use of thirds is very much a guide – anywhere between thirds and quarters is just as good. Though useful, this rule does not always have to be applied. For example, a close up of flower like that in figure 5-08 would look totally wrong anywhere else in the frame.

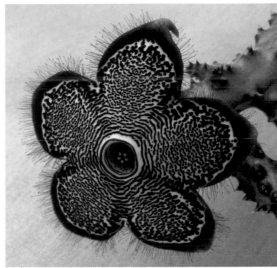

Figure 5-08: When photographing specific objects, rather than landscape or architectural scenes, the subject will usually be in the centre of the picture. Notice that excess space has been cropped from the sides of the image.

Figure 5-09: Although known as the rule of thirds (shown in red) it is only an approximation and locating features of your picture composition on the quarter lines (shown yellow) can be just as effective. Notice how the cathedral, house, riverbank and most of the skyline are all in these regions.

Subject coming into the picture

Your subject should be entering, not leaving the picture. This applies equally to people, animals, boats, trains, aeroplanes or anything else that is moving. Some photographers take this further and prefer the subject to be entering from the left rather than the right. Similarly, if the subject of your picture is a person or an animal, it should be looking into, not out of the picture.

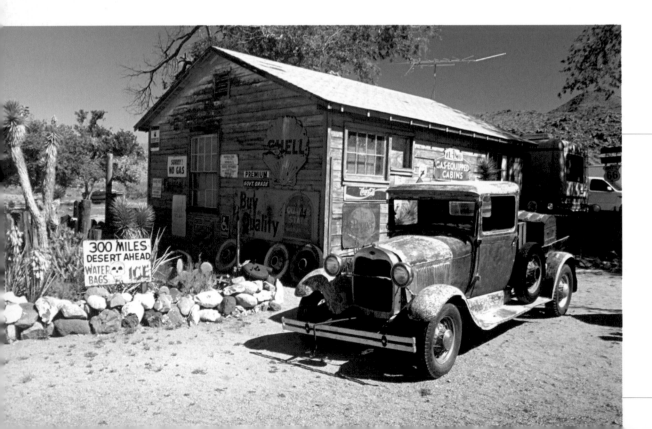

Figure 5-10: Even an old car that hasn't moved for years looks best if it is positioned as though it is entering the picture. This is true for people and animals, as well as vehicles.

Layout

If your picture contains a feature such as a road, stream, hedge or wall, try to position it so that it draws the viewer's eye into the picture. For example, if you are photographing a large building, you might try to use the driveway to lead the viewer's eye towards it. Straight features like some driveways can be striking and effective, but a meandering feature is usually more pleasing. Diagonal features are often better than those that go straight up or straight across.

Figure 5 11: The gate leads you into the picture. Note also the horizon and the wall are near to the horizontal thirds, and the path meanders on a diagonal.

Framing and symmetry

The use of a bridge or archway to frame a
picture can improve it enormously.
Alternatively, a natural feature such as a tree
can be used to frame one side and the top
of a picture. Look for symmetry and
balance, but remember it is not essential.

Experimentation

Don't always take the first picture you see.
Experiment with different angles and
viewpoints to look for the most interesting
effect. Consider taking the picture from a
different position, or using a different focal
length lens (see Lenses, page 60).

Don't crop your subject

The main subject of your picture should not
'hang out' from the edge of your image.

Figure 5-12: The plants in the foreground and the trees at the top form an outline to frame the boat.

Watch the background

Avoid background clutter that would draw the eye away from your subject. Especially take care when photographing people to ensure there is nothing growing out of the subject's head – lamp posts or pot plants are often the worst culprits! For pictures of objects, such as vases, plants, and so on, a plain background of a contrasting colour is ideal.

Use contrasting colours

A mix of colours makes pictures more eye-catching. For example, a single red flower in a picture generally comprising greens and yellows will immediately stand out.

Figure 5-13: Always check behind your subject for plants, signposts, lamp posts etc.

Figure 5-14: Contrasting colours catch the eye in this market scene.

Light and weather

A warm sunny day, with a clear blue sky is very pleasant for the photographer, but you can get far better pictures in early morning or late afternoon. Similarly, dramatic weather can provide the best picture opportunities of all.

Figure 5-15: A moody sky and a dusting of snow set off the autumn sunshine in this view over Grasmere.

People should look natural

Try to avoid your subject staring directly into the camera; eye contact, however, is usually beneficial.

Figure 5-16: The concentration needed ensured the boy did not stare into the camera.

Figure 5-17: At weddings, always be on the lookout for moments when the bride and groom relax – they have much more atmosphere than posed wedding photographs.

Give a sense of scale

Pictures of very small or very large objects lose their impact if there is nothing to give them a sense of scale. For small objects you could use an object of known size such as a coin (see figure 5-19). For large landscape features, people, trees or even vehicles could be included.

Figure 5-18: The two people give a sense of scale to this Austrian view.

Figure 5-19: The coin provides a visual reference showing just how small these flowers are.

Shooting fast-moving objects

When taking a picture of a fast-moving object, the subject must be sharp enough to be recognisable. For the purpose of explanation, lets take a rally car as an example, although the principle is the same for any fast-moving object. The shot requires a fast shutter speed, although too fast a shutter speed will freeze everything and the image will have no sense of motion, making the rally car look as if it is parked.

Some photographers like to give a sense of motion by deliberately blurring the whole image, but that is not the best practice. It is much better to follow the car as it travels across in front of the camera, panning the camera to keep the car in the frame and firing the shutter as it goes past. That way the relative speed of the car to the camera is reduced and the image should be sharp. If a suitable shutter speed has been selected, the background will, however, be blurred by the car's motion relative to the panning camera lens – particularly if a telephoto lens is used. The result is a clear picture of the car, with a definite sense of motion caused by the blurred – and no longer distracting – background.

Figure 5-20: The head and shoulders of this canoeist are sharp, but the picture still has a sense of motion because the water and paddles are blurred.

The actual shutter speed required to achieve this depends on the focal length of your lens and the speed of the car. Too slow and the car will be blurred, too fast and the background will also be sharp. For this type of action photography you would either use a sports mode if your camera has one, or select shutter speed priority mode and nominate the shutter speed yourself (start at about 1/500th of a second and adjust as necessary from there).

If you want to use the fastest available shutter speed to freeze everything, then set your camera to aperture priority mode and select the largest aperture. There are occasions where you may choose to do the opposite of the example given above and to blur the subject while freezing the background. This was illustrated in figure 4-08 where the blurring of the waterfall stops it looking frozen (see page 88).

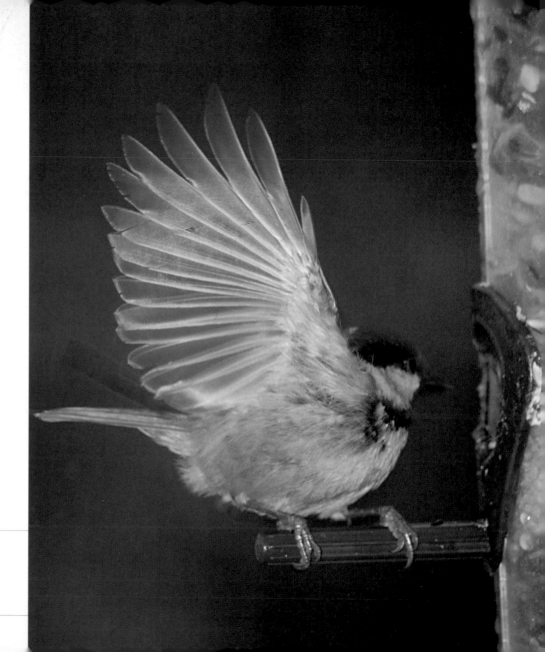

Figure 5-21: A combination of fast shutter speed and electronic flash has captured this bird feeding, but it still failed to freeze it completely. Notice the blurring of its head.

Continuous shooting

Since the introduction of the first motorised film mechanisms, sports photographers have long made use of the ability of some cameras to fire multiple exposures one after the other in quick succession. The idea is that they can anticipate when some action is about to take place, and, by firing enough shots, they can be fairly sure one of them would be taken at just the right time to catch the action perfectly.

Amateur photographers were unable to make much use of this feature, principally because it was expensive to fire off as much as a whole film in order to get just one picture. This situation has changed with digital photography. Now that buying film is no longer an issue, anyone with a suitable camera – and it must be said that not all digital cameras have a continuous shooting (or burst mode) capability – can fire off multiple shots and simply delete the surplus images at no cost whatsoever.

Figure 5-22: Sports and press photographers have long made use of the continuous shooting mode. Now, without film costs to worry about, digital photographers can also use this feature.

Typical digital SLR cameras can fire continuously at a rate of between about two and five frames per second. However, there is a limit to the number of shots that can be taken in a single burst. Because the camera can record images quicker than the data can be written to the memory card, it is initially stored in a temporary buffer. Under normal conditions, the data is transferred from the buffer to the card before or while the next shot is being taken. However, there is insufficient time for this to happen during continuous shooting and so the buffer will eventually become full and further shooting is prevented until it clears. The actual number of shots depends on a number of factors, including camera buffer size, the write speed of the memory card and the file format and size being recorded.

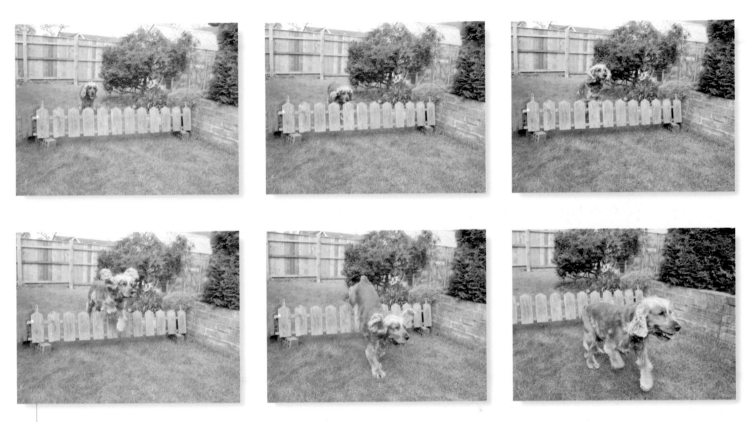

Figures 5-24a-f: Continuous shooting enables you to take a sequence of shots capturing the action from a moving subject.

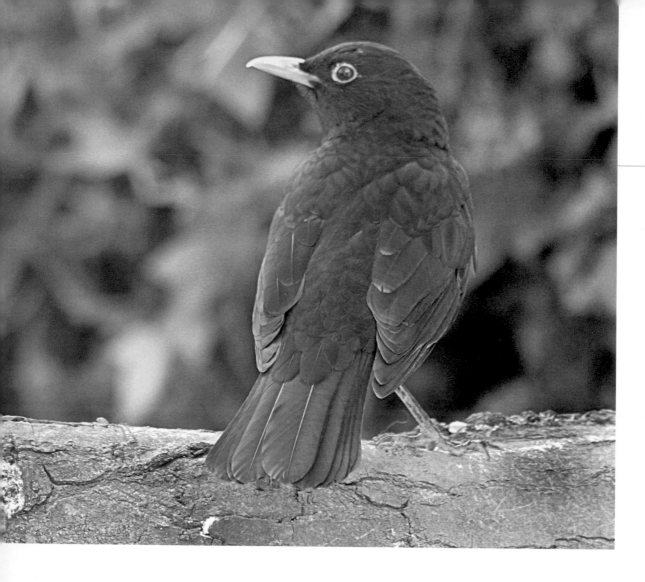

Figure 5-25: Taking several shots using the continuous burst mode is helpful when photographing wildlife.

Using the self-timer

Many cameras have a built-in self-timer feature, designed to enable you to include yourself in your pictures.

Figure 5-26: The camera's self-timer is useful when everyone wants to be in the picture.

You can arrange the rest of the family group, set the camera, start the self-timer and then you have about 10 seconds or so to take your place in the group. Lone hill walkers on the tops of mountains often use this tool to record their exploits. Another use of the self-timer is when using a tripod-mounted camera. Rather than risk camera shake when the shutter button is pressed, the self-timer can be set so you do not need to touch the camera at the time the shutter is fired.

When using the self-timer, take care not to stand in front of the lens when setting the camera; it could focus on you in your temporary location, instead of on the intended subject. Also, if using an SLR camera, you should always cover the viewfinder to prevent light entering the camera and affecting the meter reading (remember the viewfinder is usually shaded by your eye while a picture is being taken).

Chapter 6:

From Camera to Computer

Once you have taken your photographs you need to download them from your camera. Depending on the equipment you have, there are several possible ways of achieving this. Remember that, even if you carry a spare memory card, there is still a limit to the amount of memory available to you and so there may be times when you need to free up space to take more pictures when you are not near to a computer in your home (see Camera memory cards, pages 68).

Direct link to a printer

If your camera and printer (or memory card and printer) are compatible you can transfer your images directly to the printer. If you have a portable printer, this can even be done while you are away from your home. In addition to limiting your ability to carry out any image editing, the problem with direct printing is that you will have a print of your picture, but unless you leave the image file in your camera's memory, it will be deleted and lost for future use.

Direct link to a computer

Connecting your camera directly to a computer (which, in the case of a laptop computer, could be done away from your home) is a far better option. You can transfer your images onto the computer's hard disk and delete them from your camera. Once on the computer they can be printed, edited, or archived for future use.

Most photographers record their images in the camera's memory card, and then download them as a batch later. However, if you are taking a lot of pictures in the vicinity of your computer you may be able to connect your camera to it and store your images directly onto your computer. Indeed some cameras can be controlled by a computer for, say, time-lapse photography.

You will need to ensure that your camera and computer have compatible connections. These are most likely to be either USB or FireWire. All modern computers have USB ports; many will also have a FireWire port. If you are using an older computer you may need to get an interface card fitted.

The transfer process is simple: turn on the computer, connect the cable from the camera and set the camera to playback.

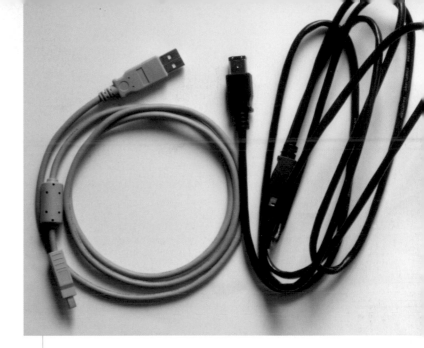

Figure 6-02: Connection to a computer may be via a USB (left) or a FireWire cable (right).

What happens next depends upon your equipment, but typically a dialog box will be displayed on your computer asking what filenames you want to use for the pictures, which folder you want to put them into, and whether you want to delete them from the camera after they have been copied across. You may be offered the chance to select individual or multiple images for transfer, and be given the opportunity to rotate them if they were taken in portrait format.

Card readers

If your camera uses a removable memory card you can take it from your camera and plug it into a card-reading device. Early card readers were often designed for a specific type of card, but newer models usually incorporate several different slots enabling a selection of different cards to be plugged in. As there are many different types of card available nowadays, you must check that yours is compatible.

Card readers can either be freestanding, connected to a computer, printer or other device via a cable (usually USB, but sometimes FireWire), or they may be built-in

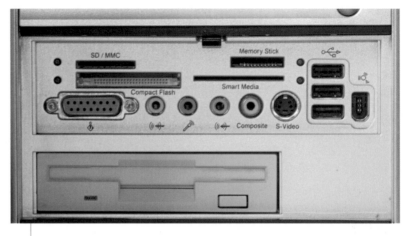

Figures 6-03: Many new computers have a built-in card reader that can read from several different types of memory card, as well as USB and FireWire ports.

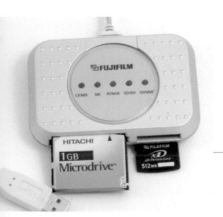

Figures 6-04: USB card readers, even those that read several different card types, like this FujiFilm DCR-71 7 in 1, reader, are not expensive.

to a computer or printer. Freestanding card readers are quite cheap to buy, costing as little as a few pounds.

The readers merely provide a method of connecting the memory card to the computer or printer. Once the connection is made, the images can be downloaded generally as described previously for a direct cable connection.

Portable hard disk drives

Although small and easy to carry, memory cards are quite expensive; particularly the higher capacity ones above 1 gigabyte (GB). Although you may choose to carry one or two spare ones, therefore, you may not want to purchase a large number of them. Computers, even the most modern notebook type, are unsuitable to carry about, so if you are going to be out and about, and expect to take a large number of pictures, you need some other way to download and store the images.

Approximate capacity of a 128MB memory card		
Camera	File format	Images
3 megapixels (MP)	Low compression JPEG	80
	RAW	35
	Uncompressed TIFF	15
4MP	Low compression JPEG	60
	RAW	26
	Uncompressed TIFF	11
5MP	Low compression JPEG	50
	RAW	22
	Uncompressed TIFF	9
6MP	Low compression JPEG	45
	RAW	20
	Uncompressed TIFF	8

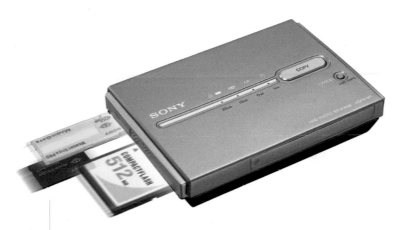

Figure 6-05: Portable hard disk storage like this 40GB capacity Sony HDPS-M1 enables pictures to be downloaded from memory cards, even when you are away from your computer.

The answer is a portable hard disk drive. There are a number of these on the market, made by several different companies. In essence they consist of a small hard disk drive – similar to those used in a computer – and usually have a built-in rechargeable power source, some of which can be recharged using a lighter socket in a car. They aren't cheap to buy, but they cost much less per megabyte (MB) of storage capacity when compared to memory cards. Some can be connected directly to your camera, some have slots for memory cards and others may need to be used in conjunction with a card reader.

Chapter 7:

Scanners

If you are new to digital photography, but have a history of taking conventional photographs, you may wonder what to do with your archives. Perhaps you want to convert some or all or your images to digital format. There are many possible reasons for wanting to do this: maybe you want to make your own prints or perhaps you want to clean up or edit the images; you might be compiling a digital album of a member of your family and want to include pictures from when he or she was younger; if you give slideshows to groups or societies, it will take time to build a new digital library and you will want to continue to draw on your existing archive of pictures. The solution to all these situations is to use a scanner to produce digital images from your existing prints, negatives or slides.

Home or professional scanning?

If you need extremely high-quality scans, or you only want a small number of pictures scanned, you might consider getting them done professionally. However, if you already have a computer, and you have a lot of scanning to do, you would be wise to consider investing in a scanner of your own.

Professional scanning may be done using high-quality drum scanners. These offer the best quality, but they are far too expensive for amateur photographers to consider and are complicated to use – the film has to be coated in oil and taped to the drum.

Things to consider when buying a scanner

Q: What type of scanner should I buy?

A: Flatbed scanners are the most common and are useful for scanning photographic prints. Although adapters can be used with flatbed scanners, if you have a significant number of negatives or slides, you should consider a film scanner.

Q: What can I scan?

A: Most flatbed scanners will scan up to a maximum of A4 size. Larger units are very expensive. They can scan colour or greyscale images or text. If used in conjunction with a Transparency Media Adapter they can also scan slides and negatives. Film scanners can only scan slides and negatives in a range of sizes and formats.

Q: What is the maximum resolution of the scanner?

A: The higher the resolution (usually expressed in dots per inch or dpi), the better the image quality should be. You should also look for maximum density value. Ideally this should be in the range 3.6 to 4.

Q: How can I connect my scanner to my computer?

A: The fastest data transfers are via FireWire or USB 2.0 connections. Alternatives include the slower USB 1.1, SCSI and, on older models of scanner, parallel port connections. Check that your computer and scanner are compatible without the purchase of additional interface cards.

Q: What software comes bundled with the scanner?

A: Scanners come supplied with interface – TWAIN – software. This usually allows some degree of basic image adjustment prior to the scan. Some are also bundled with image-editing, photo album and/or optical character recognition (OCR) packages.

Q: Is it self-contained or do I need to buy accessories?

A: Transparency Media Adapters are not usually included with flatbed scanners. Adapters for using film sizes other than 35mm may be required for film scanners.

Flatbed scanners

If you own a computer you may already own a flatbed scanner. These consist of a glass plate onto which you place the document to be scanned. They are useful for scanning a photographic print, although if you have access to the original negative you would be wise to scan that instead. Photographic prints do not have the same resolution as the negative and can have a colour cast. In addition, they may have faded with age, or been damaged during handling.

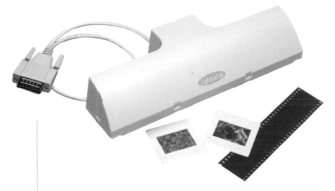

Figures 7-02: The Microtek LightLid 35 is an accessory for scanning 35mm slides and filmstrips using a flatbed scanner.

Figures 7-03: Modern flatbed scanners like this Canon CanoScan LiDE50, are very slim compared with earlier models.

Flatbed scanners do not have sufficient resolution to scan a slide or negative satisfactorily by putting it directly on the glass. However, some can be used with a dual-purpose attachment called a Transparency Media Adaptor. This provides a light source within the scanner, which enables film to be scanned. Most cheaper flatbeds do not have sufficient optical resolution to create high-quality scans from 35mm film, but if you only need a low-resolution scan they provide a fairly low-cost option.

If you intend to purchase both a scanner and a printer, another option is to buy an all-in-one device that scans, prints, acts a photocopier and can send faxes. These tend to simplify the setting up of your system, but you will have less choice over their specifications than if you bought separate devices.

Film scanners

As with much of the equipment described in this book, the quality of film scanners has increased in recent years, while the price has fallen. They still remain quite expensive, but if you have large numbers of slides or negatives that you want to scan then they are a very useful investment.

Although a film scanner scans the very small image on the film, it is designed to scan at much higher resolutions than a flatbed scanner so the image quality is better than that obtained by

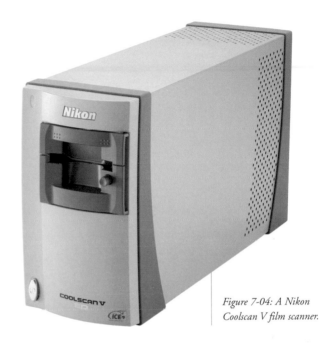

Figure 7-04: A Nikon Coolscan V film scanner.

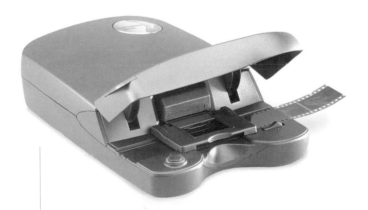

Figure 7-05: A Jessops 3650U film scanner showing how a strip of negatives can be inserted.

scanning a typical photographic print. Most are supplied with special adaptors and carriers that allow mounted 35mm slides or unmounted filmstrips to be scanned. Many film scanners have the facility to batch-scan several images from strips of film. Some units will scan other film sizes, such as medium format or Advanced Photo System (APS), but if you want to scan these you must check when choosing your scanner.

Scanner resolution

Scanner resolution is usually specified in dots per inch (dpi), although samples per inch would be more accurate. As with cameras and printers, the higher the resolution, the better the potential image quality. It is important to use the value quoted for optical or true resolution, as opposed to interpolated or enhanced resolution. Some scanner specifications state two figures for the optical resolution, for example, 1200 x 2400dpi. The lower figure is the actual size (and resolution) of the scanners sensors, the larger one is the minimum distance that sensor can be moved before the next scan is made. It is the lower figure that gives a true indication of the scanners resolution.

Remember that the resolution stated in the scanner's specification is the maximum it can achieve. You may choose to scan at a lower resolution, for example if the scanned image is to be put onto your website, it can be argued that there is no point creating a time consuming, high-resolution scan with its correspondingly large file size. The following formula will help you decide what is the theoretical minimum resolution you must set your scanner to scan at:

$$\text{Required scanner resolution} = \frac{\text{Width of image to be produced}}{\text{Width of image being scanned}} \times \text{Required dpi}$$

Example One: If you have a photograph 15cm (6in) wide and you want to make a print of it 20cm (8in) wide and your print quality requires an image resolution of 250pp:

$$\text{Required scanner resolution} = \frac{20\text{cm}}{15\text{cm}} \times 250 = \textbf{333 dpi}$$

Example Two: If you have a 35mm negative (size 3.6 x 2.4cm) and you want to make a 25cm (10in) wide landscape format print of it and your print quality requires an image resolution of 300ppi:

$$\text{Required scanner resolution} = \frac{25\text{cm}}{3.6\text{cm}} \times 300 = \textbf{2,083 dpi}$$

To confuse the issue, there is some debate over scanner settings. Some users advocate always using the maximum resolution just in case you want to reuse the image for another purpose in the future (although you could always re-scan it if you do). Others suggest you use the above calculation, but then add a safety margin by making the actual resolution anything up to twice the calculated theoretical value. Certainly you would not use numbers like 333 or 2,73dpi, you would always round them upwards. You would be well advised to experiment to establish the optimum to suit your particular needs.

Typical scanner resolutions	
Scanner type	Resolution (optical)
Flatbed	1,200 to 3,200dpi (typically 2,400)
Film	1,800 to 5,500dpi (typically 4,000)
Drum	8,000 to 12,500dpi

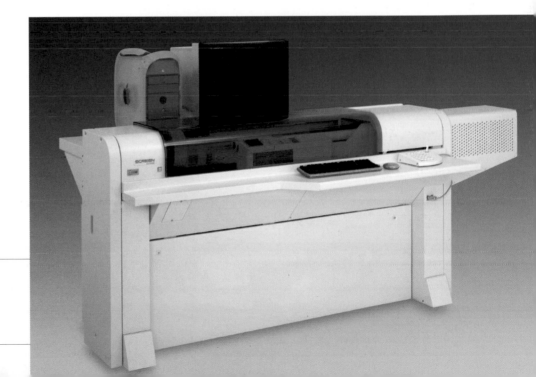

Figure 7-06: Drum scanners such as Dainippon's Screen SG-8060P give very high quality scans, but are strictly for professional use.

Scanner software

Your scanner will normally be supplied with some software. As a minimum you should be provided with interface or driver software, although with some 'plug and play' equipment this may not be necessary for computers running recent versions of the Microsoft Windows operating system. The interface software often enables you to do a pre-scan and preview the image in order to set some basic parameters prior to the scan. Some scanners are also bundled with image-editing or photo-album software packages.

Sooner or later you will come across the expression TWAIN or TWAIN driver. Strictly, TWAIN refers to the interface standard for data transfer between your scanner or digital camera and your image processing software. However, just think of it as a piece of software that you use during scanning.

Figure 7-07: Always keep the disks that come with your equipment in a safe place. You may need to re-install the software in the future.

The scanning process

The following description of the scanning process describes how a scan is made using a Nikon Coolscan film scanner; however, the process is similar for a flatbed scanner. The slide or negative is inserted into the scanner and the scanning software is launched from the Windows Desktop (it may have its own icon, or you may have to access it via the Programs menu by clicking on the Start button). If your scanner does not have its own dedicated software, you can usually scan from within your image-editing software package (see figure 7-08) or via the Scanners and Cameras item in the Windows Control panel.

Figure 7-08: Images can be imported directly from a scanner into your editing software.

Figure 7-09: The pre-scanned image is displayed in Nikon's Coolscan software; the settings can be adjusted and previewed before the final scan is made. In this case the amount of red needs to be reduced.

Click the button marked Preview (or sometimes Pre-scan). This initiates a quick, low-resolution scan of your photograph, which is displayed on your screen. At this point you can adjust the various scan settings – including colour balance, brightness, contrast and resolution, in addition to rotating or mirroring the image and defining any cropping that may be necessary. Some scanner software packages incorporate special features (such as the Digital ICE cubed software) that improve the quality of

Figure 7-10 Nikon's Coolscan software allows many settings to be adjusted to get your scan just right. Not all the options are displayed – notice the drop-down menus that allow access to even more controls.

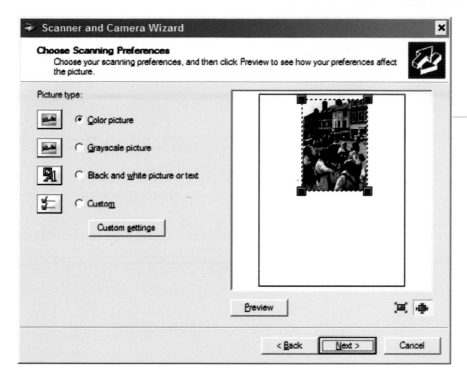

Figure 7-11: The pre-scan dialogue for a flatbed scanner using Windows Scanners and Cameras from Control Panel. The custom settings allow the resolution, contrast and brightness to be adjusted, but that is all.

Figure 7-12: The Hewlett Packard PSC 2355 is both a scanner and a printer.

your scanning by cleaning images from film that is suffering from dust or scratches, or is faded, and which reduces the effect of the grain structure of the film. Once you are satisfied with the settings, you click the Scan button, input the required name for the file, and the actual scan is made.

Typically, there would be fewer controls available in the software for a flatbed scanner. This is particularly true if no dedicated software has been installed and you are relying upon the interface provided by the Windows Control panel.

Chapter 8:

Equipment and Software for Digital Imaging

Although it is possible to take digital photographs and print them directly from a memory card, it is far better to download them onto a computer and manipulate them using image-editing software. This enables you to print just what you want, cropping and enlarging as required, and allows you to work on the images and make improvements to them. With practice you can even combine them to make whole new pictures. Some professionals use computers running Macintosh software, but since the huge majority of personal computers – including those owned by most readers of this book – use the Microsoft Windows operating system, that is what will be described in this chapter.

Figure 8-01: A workstation set-up suitable for digital photography, comprising camera, computer and printer on the desk, with an external Zip drive, plus flat-bed and film scanners on the shelf.

Figure 8-02: A desktop computer system, comprising tower unit, monitor, keyboard, mouse and speakers.

Hardware

Although nowhere near as demanding as modern games software in terms of computing power, image editing – particularly of high-resolution images – does require a reasonably powerful computer. If you already have a home computer, try editing a few images and you will quickly find out if it is good enough for the task. If not, you will become frustrated by the time it takes to carry out even basic commands. Before giving up on your old computer, you may find that the installation of additional memory can result in a dramatic improvement in performance at relatively little cost.

If you intend to purchase a new computer, the best advice is to get the highest specification you can afford. The following advice may be of some assistance in selecting a suitable computer, although do be aware that computer technology is developing rapidly, and many specifics written here will have become out-of-date by the time you read it.

Memory

It is most important that your computer has plenty of memory (called Random Access Memory or RAM). Just a few years ago 128 megabytes (MB) of memory was considered a huge amount, now 256MB is the absolute minimum you should accept, and 512MB or even 1 or 2 gigabytes (GB) is preferable for image editing. Be careful with terminology here: this memory is used for the temporary storage of the computer's working files. Data stored in RAM is lost when the computer is switched off. It should not be confused with file storage on your computers hard disk – even though the latter is sometimes also referred to as memory. To ensure your images update rapidly, you should look for a computer with a video card (the component that is responsible for displaying the image on your monitor) with plenty of its own dedicated memory: at least 128MB is preferable.

Figure 8-03: Fitting extra memory may help the performance of your computer.

Processor

The speed of the computer's central processing unit (CPU) is perhaps less critical than the amount of memory. Despite that, it is usually the processor type (for example Intel's Pentium or AMD's Athlon) and speed, measured in megahertz (MHz) that forms the headline of the computer's specification. It is unlikely that any new computer would be sold with less processing power than you require for typical image editing.

Figure 8-05: Floppy disks are too small for digital images, but there are other methods of portable storage. These include CD-ROMs, USB flash memory and Zip disks.

Hard disk

Plenty of hard disk space is vital as image file sizes can be large, and in time you will accumulate many pictures. However, the capacity of a modern hard disk is usually sufficient even for video editing – they are often in excess of 100GB, and sometimes as much as three times that – so you should not find yourself too restricted for the purposes of digital photography as long as you archive images fairly regularly.

Storage

Whatever you buy, you will need some way of getting image files off your hard disk and storing them for future use. Floppy disks are useless for this purpose as their capacity is far too small. Alternatives include flash-memory drives and Zip disks. A more, realistic option is an optical drive to enable you to burn compact disks (CDs) and/or digital versatile disks (DVDs). These provide a low-cost method of archiving your image files. A CD-ROM can hold up to 700MB of data, while a DVD-ROM can store up to 4.7GB. Be careful when buying DVD-ROM disks, as unlike CD-ROMS, there are rival formats that may not be compatible with your DVD-writer.

Monitor

The resolution of CRT monitors is – within limits – set by the user. However, TFT monitors are designed to be used at a specific resolution and the setting should not be changed. You should look for a minimum TFT monitor size of 38cm (15in) with a resolution of 1024 x 768. Because the viewable size of CRT monitors is always less than the specified size, a 43cm (17in) monitor is the smallest you should consider buying.

For many years desktop computers used bulky cathode ray tube (CRT) monitors, while laptops used liquid crystal display (LCD) screens. New computers are now being supplied with flat panel thin film transistor (TFT) monitors; these are a form of LCD, and deliver a good-quality, flicker-free, TrueColour display. One disadvantage of TFT monitors is the tendency for colours to appear differently, depending on the position of your eyes relative to the screen. Whatever you choose, ensure the screen is flat (some of the cheaper CRT monitors have curved screens) and buy the largest, highest resolution you can afford.

Figure 8-04a & b: Increasingly CRT monitors (top) are being replaced by slim, flat screen TFT monitors (bottom).

Laptops

One question you might consider is whether you would be better off buying a laptop (sometimes called a notebook) rather than the more conventional desktop computer. A laptop will typically have a much lower specification than a desktop computer costing the same amount of money. In addition they cannot be upgraded so easily or cheaply if you want to expand their specification in the future. On the other hand, modern laptops incorporate screens that are large enough and of good enough quality for this type of work and their portability means they can be used to download camera images when you are away from home, or to drive a digital projector if you want to give slide shows.

Figure 8-06: Notebook computers like this one from HP Compaq are portable but still have high quality graphics.

Monitor calibration

It is important that you calibrate your monitor, that is, set it up to display colours, brightness and contrast properly. There is little point spending time getting the colours just right on your computer screen if the pictures look completely different on another machine, or when they are printed out.

Although the calibration adjustments are easy to make, and are simple in principle – you vary colour, brightness and contrast until your monitor displays the same as any other correctly calibrated monitor – in practice, it's a little more difficult, and there are several reasons for this:

- The amount and colour of the ambient light in your room can affect how your eyes perceive the colours on your monitor. You should calibrate your monitor in the same lighting conditions you have when you are working at your computer. Bear in mind that, ideally, you should work in subdued lighting of a neutral colour, but not in the dark.

- If you are using a TFT screen, the position of your eyes relative to the monitor affects the image coloration. Ensure you are sitting in your normal working position when doing a calibration. If you are using a CRT monitor, the colours will vary slightly as it warms up. Ensure it has been switched on for at least 15 to 30 minutes before calibrating it.

- There are different ways of calibrating: you can calibrate via your video card using utility software, using your monitors controls, or specifically within a particular software package.

Many digital cameras are shipped with a copy of Adobe Photoshop Elements. If you have this – or other Adobe software – installed on your computer, then you will probably find that you have the Adobe Gamma Control utility installed within the Windows Control panel. From your Windows desktop, access Control Panel via the Start menu and check to see if Adobe Gamma is in the list (see figure 8-07). If it is, double click it to run the utility.

Figure 8-07: The Adobe Gamma utility is launched from within Windows Control Panel.

If you use the wizard, you will be guided through the process of calibration. Alternatively you can simply adjust the settings using the screen shown in figure 8-08. Set the White Point to 6500K (daylight) and adjust the Gamma sliders until the central square in each of the calibration boxes blends with the surrounding colours. Use the checkbox to alternate between the single Gamma and RGB views. You should switch between these several times, fine-tuning the settings for the greatest accuracy. When your adjustments are complete, check the Brightness and Contrast bar – you should just be able to make out a series of alternate black and dark grey squares on the upper stripe of the bar. The other settings (for example, Phosphors) can be left set to Custom unless you know the specific characteristics of your hardware. Click OK to save your settings.

Figures 8-08a & b: The Adobe Gamma utility calibration screens.

Because the Adobe Gamma utility is loaded whenever you start Microsoft Windows, your calibrations will affect your entire system and all the software running on it. Remember to recalibrate if you change your monitor, or if you move it to a different location.

The second way to calibrate your system is to adjust the settings of your screen manually. This is normally done via buttons located below the viewing area of your monitor. To do this you need a calibration chart, if you have Internet access, a search for monitor calibration will reveal several web pages that include the necessary features and instructions. The process is similar to that described above, in that you will be instructed to alter settings until you can or can't see differences between black, white, grey and coloured areas.

Whether or not you have calibrated your system as a whole, some individual software packages include their own calibration system. An example of this, from JASC's Paintshop Pro, is given in figure 8-09. Once again, the sliders are adjusted until the central rectangles blend with the surrounding coloured regions.

The advantage of calibration within a software package is that, if you do not have the Adobe Gamma utility (or similar) installed, you can still calibrate to view the images correctly within your editing software. The disadvantage is that it is package-specific, so even if you have calibrated your whole system, your images will not be displayed correctly unless you also calibrate the editing package.

Figure 8-09: Paintshop Pro's monitor gamma adjustment screen.

Figure 8-10: Take care when using a keyboard and mouse to avoid the risk of repetitive strain injury.

Working at your computer

You may spend a considerable amount of time working at your computer and so you need to take some simple health and safety precautions:

- Ensure your computer is located in a position where you will be comfortable while you are working.
- Use a good-quality chair that gives support and ensures a good posture.
- Ensure your monitor is positioned to give a comfortable line of sight (the top of the monitor should be at eye level), is the correct distance from your eyes (roughly at arms length) and is free from reflections – shield your monitor from direct light from windows, for example.
- Your keyboard should also be comfortably located. If possible, use wrist supports.
- Do not grip your mouse too tightly. Consider using a graphics tablet as an alternative.
- Cables can be a trip hazard. Always consider electrical safety and avoid using damaged cables or overloading power supplies.
- Take regular breaks.

Software

There are many software packages available to help you edit and display your images; there are too many to list here and they are constantly being updated. In practice, you may already have suitable software on your computer, or it may be supplied free when you buy a camera or scanner. If not, the following brief outlines of some of the more common editing packages may prove helpful to you in making a selection. Remember that the newer the version of the software, the more features it will have. On the other hand, older versions can often be bought or downloaded rather more cheaply and they may still do everything you require. At the very least, older versions allow you to try out a piece of software and upgrade to a newer edition at a later date, if you like it.

- **ACDSee:** A popular, budget-priced package, albeit with limited functionality compared with some of the higher-specification packages.

- **Adobe Photoshop:** The industry standard software for professionals, it can be used with either Macintosh or Windows operating systems. It is the most powerful editing package around, with a huge number of available plug-ins (small pieces of add-in software that give extra functionality). This power comes at a price and the software is very expensive to buy. In addition it requires the resources of a high-specification computer to run it on, and it is complicated to use.

- **Adobe Photoshop Elements:** A cut down version of Photoshop that is better suited to amateur use. It is much cheaper, but retains good functionality and compatibility.

- **Corel PhotoPaint:** Incorporates high-level functionality, but because it is bundled as part of a suite of graphics software, it is expensive to buy.

- **JASC Paintshop Pro:** Very popular software offering professional features at an affordable price. It still incorporates good functionality and compatibility, but is easier to use than Photoshop.

- **Microsoft Digital Image Pro:** Simplified tools and incorporated templates allow easy personalisation of your images, but its functionality is limited.

- **Microsoft Photo Editor:** This software came as part of Microsoft Office before 2003, so you may already have it on your computer. It has limited features compared with the more powerful editing packages.

- **Microsoft Picture It!:** A cheap and easy-to-use package useful for beginners. Like Photo Editor, it has very limited functionality compared with the likes of Photoshop or Paintshop Pro.

- **Roxio PhotoSuite:** Another budget image editor with limited functionality. It is, however, good for beginners because of its easy to use, wizard-driven, interface.

- **The Gimp:** Available free of charge. It has an unusual interface that makes it a little difficult for some users. It does not incorporate an image browser.

- **Ulead PhotoImpact:** Cheap to buy, but with plenty of functionality. It incorporates a choice of modes to assist beginners until they become more familiar with editing techniques.

Some of the above, including Photoshop and Paintshop Pro include browser software, enabling you to view small thumbnail images and manage your files. This can be a great help when trying to keep track of a large collection of images. It is not a critical feature, though if you are using a recent version of Windows, you can change the view setting in Windows Explorer to display thumbnails.

In addition to image-editing packages, there are other types of software that you may consider useful. These include album software to organise your images, presentation software for making slideshows, calendar and card creation software, and a whole range of utilities for, among other things:

- Cataloguing and managing your images
- File format conversion
- Producing CDs or DVDs of your pictures
- Making screensavers or puzzles from your pictures

Chapter 9:

Editing and Storing your Images

Although every image-editing software package is different, most of the basic principles are common to them all. What varies from package to package is higher-level functionality. This chapter introduces beginners to a few useful techniques that merely scratch at the surface of the capabilities of imaging software. From here you can experiment for yourself, or, if you become one of the many digital photographers who find image editing as rewarding as picture-taking, you might decide to take a course at your local college. Another useful source of learning is video tutorials, which can often be found on the cover-disk of specialist magazines.

Editing procedures

You should bear in mind that, although the basic procedures will be similar, the location of the controls and the specific methods will vary depending on which software package you are using. Several of the techniques shown involve the use of layers. These allow multiple images, or image adjustments, to be superimposed on one another until the desired effect is created. Once complete the image can be saved within the software's native file format and the layers preserved to facilitate further editing. Alternatively, the image can be flattened – that is, saved as a single layer with the changes incorporated, but with no future adjustments possible.

 Always carry out your editing on a copy of your image file, not the original. That way, if you are unhappy with the results of your efforts, you have lost nothing and can delete the copy, duplicate the original and start afresh.

Re-sizing and re-sampling

In conventional photography, if you wanted a larger or smaller copy of a picture, it was achieved by changing the distance from the enlarger lens to the printing paper, hence altering the magnification without affecting the amount of detail in the picture. The digital equivalent is re-sizing, that is, changing the resolution of the image by scaling the size of each pixel.

There is considerable confusion between re-sizing and re-sampling. When re-sizing, the number of pixels in the image remains unchanged. When re-sampling, the actual number of pixels that make up the image is increased or decreased. This is done by means of an arithmetic calculation. It is reasonably successful if the pixel count is decreased, but less so if it is increased: the computer has to guess what colours to make the extra pixels. It is therefore advisable to take your pictures at the pixel count that you require, rather than adjusting it later.

Changing the image's pixel count must not be confused with zooming in or out to change the way it is displayed on your monitor. When you zoom in, the number of pixels in your image remains unchanged, they are simply displayed larger on your screen. This is illustrated in figure 9-01.

Figure 9-01a&b: These two pictures are of the same image, but the one on the right has a much lower pixel count. To display it the same size the pixels are enlarged and are clearly visible.

Rotating an image

There are times when you will need to
rotate an image. The most usual is to turn
an image taken in portrait format through
90 degrees to display it the correct way up
on the screen. You may also want to turn
an image slightly to correct its horizon
(see figure 9-02). This is achieved below
using Paintshop Pro. It is important to
remember that applying a transformation
such as Rotate results in an interpolation
of the pixels in your image, and hence a
slight degradation of image quality. Never
apply the transformation a second time – if
you don't get the angle correct the first
time, use the Undo command and apply a
different angle of rotation.

*Figure 9-02: This picture
was taken from a moving
boat on Lake Powell in
Utah. The movement of
the boat caused the horizon
to fall towards the right
hand side of the picture.*

Method

1. With rulers displayed, a guideline is dragged near to the horizon providing a
 reference for alignment (figure 9-03).
2. The Rotate command is selected from the image menu. Select the required angle of
 rotation from the dialog box (figure 9-04).
3. The rotated image looks better (figure 9-05), but it must be cropped (see page 180).

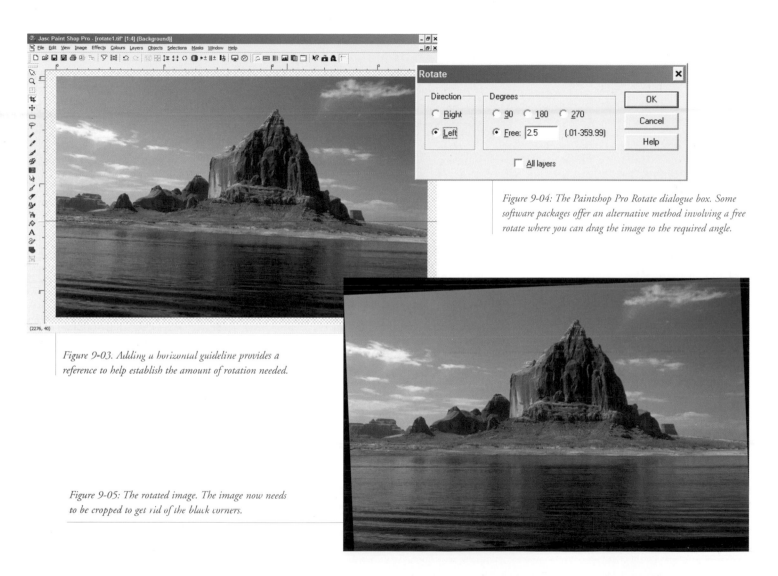

Figure 9-04: The Paintshop Pro Rotate dialogue box. Some software packages offer an alternative method involving a free rotate where you can drag the image to the required angle.

Figure 9-03. Adding a horizontal guideline provides a reference to help establish the amount of rotation needed.

Figure 9-05: The rotated image. The image now needs to be cropped to get rid of the black corners.

Cropping

You may want to crop an image to straighten the edges following a rotation. Alternatively, you may just want to improve an image by removing a distracting part of the picture.

Method

1. Using the Crop tool, a rectangle is drawn on the picture. The outline defines the new shape of the image. Use the mouse to adjust it until it is exactly right (figure 9-06).

2. Place the cursor within the rectangle and double-click the left mouse button to remove the unwanted areas (see figure 9-07).

Figure 9-06: Using the Crop Image tool, a rectangle is dragged over the picture. The outline is adjusted, using the mouse, until it is exactly the required shape and size.

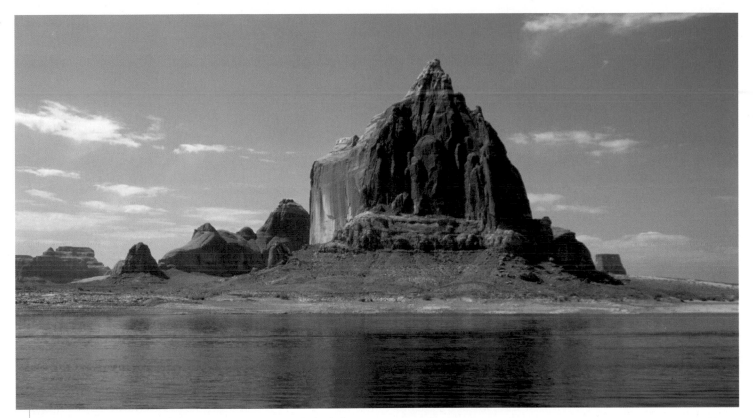

Figure 9-07: The surplus parts of the image are removed, leaving the finished picture

Although not strictly cropping which reduces the size of an image canvas by cutting away unwanted areas) another useful technique is to remove unwanted or distracting backgrounds. A good way of doing this is to make the image fade away from your subject, as shown overleaf, using Photoshop. (It should be noted that experienced Photoshop users would not use this simplified method. A more complicated approach, involving the overlaying of a mask, would give a similar result while retaining the image properties and enabling adjustments to be made later, if required.)

Figure 9-08 (left): The people behind the dancer in this picture draw the viewer's eyes away from the main subject.

Figure 9-09 (right): The centralised image.

Using Photoshop

Method

1. Use the elliptical marquee tool to outline the part of the image to be retained. Invert the selection using inverse from the Select menu.
2. Choose feather from the Select menu and a suitable radius – 100 pixels in this case, but experiment.
3. Press Delete to clear the background and the feathered edges will blend gently into the background.
4. Crop the background to centralise the image (figure 9-09).

Sharpening and blurring

The more you edit your images, particularly if you use commands that involve interpolation (for example scaling, rotating by other than 90 degrees or changing the perspective), the softer they gradually become. Similarly, images from your camera or scanner may not be perfectly sharp. Although there is no way of recovering data that is not present in the image, editing software has a tool that can make the image appear to be sharper. It does this by increasing edge contrast (darkening the darker side and lightening the lighter side of an outline). The opposite of sharpening is blurring. Blurring can be used in a number of ways, one of which is to blur distracting parts of the image – usually the background.

Figure 9-10: This picture of Lincoln Cathedral would benefit from a little sharpening.

Figure 9-11: This image shows the effect of overdoing the procedure.

Photoshop Manipulation

Method

1. The entire outline of the dancer is selected. There are several ways of doing this, including careful use of Marquee, Lassoo and Magic Wand tools (the shift key is held down to add extra areas to the selection). The selection is then inverted by using Inverse from the Select menu, so that everything except the dancer is selected (figure 9-12).

2. Use one of the Blur choices (in this example, Gaussian blur) from the Filter menu to blur the background of the image. The amount of blurring can be adjusted while watching the effect in the preview until the right effect is obtained (figure 9-13).

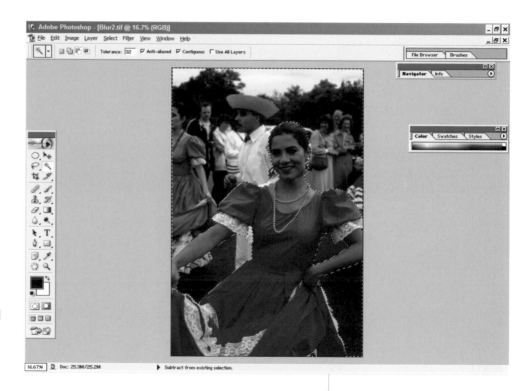

Figure 9-12: The selection is then inverted.

Figure 9-13: The background is blurred so it is still visible, but it is much less distracting. The same effect could have been created in the camera by using a wider aperture to reduce the depth-of-field.

Red-eye removal

As mentioned previously, a red-eye effect can result
when the camera's flash reflects back from the eyes
of the subject (see When not to use flash, page 104).
Thankfully, editing software packages often include
an automated tool to correct the problem, as shown
below, using Microsoft Picture It! Some of the more
sophisticated software packages allow for manual
adjustment of the correction settings, including
human eyes or animal eyes, the size and lightness
of the glint in the eyes and even for eye colour.

Method

1. From the Common Tasks pane select Fix Red Eye.
2. From the Touchup category (see figure 9-15).
3. The cursor beam becomes a cross-hair and each
 affected eye is clicked in turn.
4. The Red-eye auto fix command is clicked and the
 correction is done automatically.

*Figure 9-14 (above): The reflected light from the direct
flash has made the subject's eyes appear red.*

Figure 9-15 (above): The Microsoft Picture it! command used to initiate the red-eye correction.

Figure 9-16 (right): The image is much more flattering after being processed using the red-eye reduction tool.

Adjusting brightness, contrast and colour

Despite the best efforts of camera and photographer, the captured image is sometimes just not quite right. It may need the brightness, contrast and/or colours adjusting slightly. Increasing the contrast makes shadowed areas darker, although if adjusted too high there is a loss of visible detail in them. Decreasing the contrast too much tends to make the image lose impact and look flat and muddy. A related control is Gamma, which is a method of tonal correction that shows detail in a low-contrast image without significantly affecting the shadows or highlights. Figures 9-17 to 9-19, show the effects of varying contrast and brightness.

Figure 9-17a: This picture of a rose has quite a high, but acceptable contrast.

Figure 9-18: When the contrast is pushed up even higher, the colours become very rich, but detail is lost in the dark areas.

Figure 9-19: When the brightness is increased excessively it becomes flat and muddy.

Figure 9-20: The slider controls in Microsoft's Photo Editor.

Figure 9-21: Although no longer bearing any resemblance to reality, colours can be adjusted to create artistic effects.

Depending on the level of complexity of the software, these adjustments may be made using a simple set of sliders (see figure 9-20) taken from Microsoft's Photo Editor software), or a very complex set of controls applying separate adjustments to highlights or mid-tones and individual colour channels within selected areas of the image.

The amount of red, green and blue in the image can also be adjusted in a similar way. This is usually done in an attempt to give a true rendition of the original subject, particularly skin tones. However, adjustment of colours can also be used as a special effects tool, as shown in figure 9-21.

Making monochrome images

Although most people prefer colour pictures these days, there are times when black and white (monochrome) images can provide impact. Some landscapes lend themselves to this treatment, as do pictures that have a sense of history, such as the steam train in the example below. Although some digital cameras have the option to shoot in monochrome, this photograph was taken in colour and then converted in Photoshop.

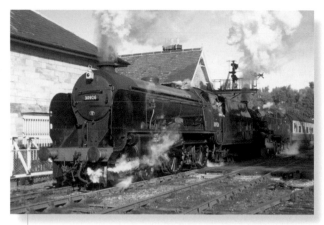

Figure 9-22: This image was produced using the quickest and easiest way to convert an image to monochrome.

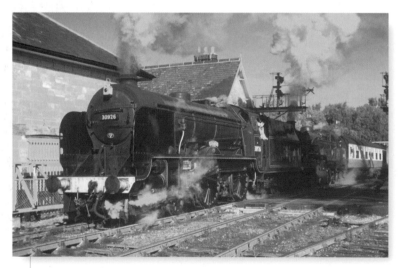

Figure 9-23: This image is much more atmospheric and was produced using a method that gives much more control over the end result.

Figure 9-24: The Channel Mixer dialog, used to adjust the appearance of a monochrome conversion.

Figure 9-22 was produced using the quickest and easiest method of converting images to monochrome. That is to use Adjustments – Desaturate from the image menu. The second picture, figure 9-23 is much more atmospheric and was produced with a method that gives much more control over the end result.

Method

1. Select New Adjustment Layer – Channel Mixer from the Layer menu (figure 9-24).
2. Check the Monochrome box and adjust the sliders until the desired effect is obtained.

The image was finally given a historical feel (figure 9-25) by adding sepia tones. This was done using Image – Adjustments and checking the colorise box on the Hue/Saturation dialog.

Figure 9-25: Colorising pictures can give them a more historical feel.

Adding text

It can be useful to add text to the occasional photograph, for example to create a title in an album or slideshow. Digitally this is extremely easy to do. Photoshop Elements is used in the example below, but most editing packages support the addition of text, although methods vary. Depending on the software package and the file format you choose, when you save your completed image, you may be given the option to save the layer structure of the image (in some editing packages the text is initially put on a separate working layer). If you choose to save the text layer, you will be able to edit it again later if required, although the file size will be larger.

Figure 9-26: A suitable picture with a plain area is selected.

Method

1. Select the Horizontal Type text tool – the text toolbar is displayed.
2. Position the cursor where you want the main title and click the mouse. A flashing cursor will be displayed.

Figure 9-27: The appearance of the text is adjusted using the Photoshop Elements controls

Figure 9-28: The completed image. Each piece of text can be formatted separately.

3. Type the required text and format it using the font and text colour toolbars. To add a special effect, click on the Create warped text toolbar. This example shows a horizontal 'Flag' style with a 40% bend (figure 9-27).
4. The position of the text can be adjusted using the mouse.
5. Repeat the process to add more text (figure 9-28).

Adding frames

If you intend to use your images as, for example, greetings cards, it can be useful to add artistic borders. Software such as Microsoft's Picture It! make this easy to do.

Figure 9-29: A snow scene is loaded into the Picture It! software.

Figure 9-30: The finished image, suitable for a Christmas card.

Method

1. Choose Frames and mats from the Edges category in the Tasks pane (figure 9-29).
2. Select the Christmas theme and choose a suitable border from the templates supplied.
3. The snow scene is dragged from the image tray onto the border. It can then be moved, scaled or mirrored to give the required effect (figure 9-30).

Cloning

Lamp posts, road signs, aerials and overhead cables have always been a major headache for conventional photographers. Although still unwelcome, they are not such a problem for digital camera users. With care, and after a degree of practice, they can be removed digitally once the picture has been taken. Using the Clone tool, adjacent patches of colour are duplicated and painted over the intrusions. How effective this can be is shown in figures 9-31.

Figure 9-31a & b: The town of Chloride in Arizona has a wild west appearance which is spoilt by the signs and bollards. Careful cloning has removed the worst offenders – the white line in the road should be removed next.

Figure 9-32: St Botolph's Church in Boston, Lincolnshire. Note the distortion caused by the use of a wide-angle lens. It was not possible to take the picture from further away.

Correcting converging parallels

An unavoidable result of tilting a wide-angle lens upwards, or downwards, is that parallel lines tend to converge. This can be clearly seen in figure 9-32 where it was not possible to stand far enough away from the church to avoid the effect. The church tower appears to be leaning to the right, while the end wall of the chancel appears to be leaning backwards. The distortion can be corrected digitally, in this case using Adobe Photoshop.

Figure 9-33: A superimposed grid is displayed using View – Show – Grid to give true vertical lines for reference purposes. The whole image is selected using Select All. Perspective is chosen from the Edit – Transform menu. An outline, with eight square handles, is displayed around the image. One of the top corner handles is dragged sideways causing the image to distort symmetrically. The amount of transformation is adjusted until the vertical lines of the church are parallel with the gridlines.

Figure 9-34: This improves the image significantly, but a side effect is that the transformation has altered the image proportions – the church tower and the statue now look too wide relative to their height.

Figure 9-35: The image width is reduced while leaving the height unaltered to restore the correct proportions. This is done using Image – Image size, remembering to uncheck the Constrain Proportions box.

Compositing

Compositing is the word used to describe the superimposing of one or more images onto another. With practice, it is possible to combine parts of several different images to make a whole new picture. It can be fun and while it takes considerable skill to make complicated composite images, it is not difficult to produce a simple composite, as shown below, using Photoshop. In the example below, a fairly plain sky behind a silhouette of an abbey is replaced with a dramatic sunset.

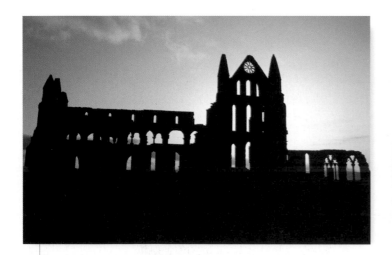 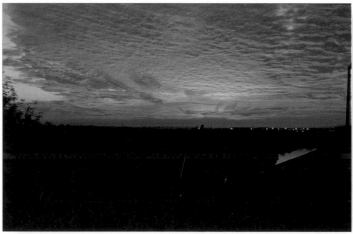

Figures 9-36a&b: The silhouette of Whitby Abbey (above left) has potential, but the sky is not very inspiring.– unlike the stunning sunset taken from the upstairs window of the photographer's home. This time the sky is superb, but as a photograph it lacks a good foreground.

Figure 9-37: The picture of the abbey is opened and is tidied up by rotating it slightly and cropping it to square it up (see pages 178 and 180). Because the silhouette is so black, it is easy to use the Magic Wand tool to select it. At this point it can be copied directly to the clipboard. However, because it is a complicated shape it is useful to confirm that the selection is correct (it is not easy to see whether the tracery in the windows has been selected). To do this, the selection is then inversed, enabling everything except the abbey to be deleted.

Figure 9-38: The selection is inversed again, to reselect the abbey, and it is copied onto the clipboard. The picture of the sky is now opened and cropped to remove the unwanted foreground, lamp post, and so on. A new layer is added using New from the Layer menu and the abbey silhouette is pasted into it. Transform – Scale is selected from the Edit menu, which allows the abbey to be re-sized to fit on the background sky; its position is adjusted to get the best effect of the light through the window arches. Finally, the surplus sky is cropped to give the image the desired proportions.

Panoramas

It is difficult to capture an entire panorama from some viewpoints, even with a wide-angle lens. In such instances you can make use of panorama stitching by taking a series of photographs that cover the whole panorama between them. The more pictures you take the better, as you should have a good overlap (ideally between 30 and 50 percent). It is preferable, but not essential, to use a tripod to ensure all the images are on the same horizontal plane. In the example below, six pictures taken without the aid of a tripod (see figure 9-39a–f) are combined into a single picture using Canon's PhotoStitch software.

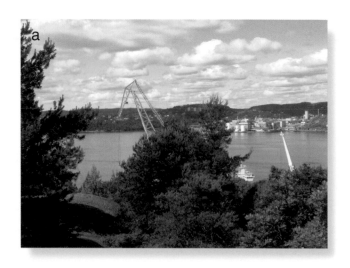

Method

1. Use the Select and Arrange tab to open all six images. They are sorted into the correct sequence.
2. Once the Start button on the Merge tab is pressed the pictures are automatically compared and overlaid to form one image (figure 9-41).
3. The Save tab shows the same image, but with a cropping outline overlaid so that you can crop to remove the jagged edges.
4. Click on the Save button to give the image a filename and save the whole image to disk (figure 9-42).

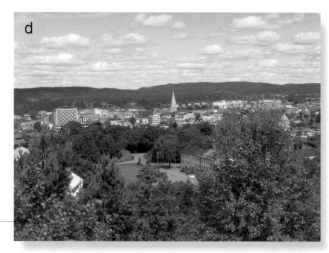

Figure 9-39 a-f: Six pictures taken at a viewpoint overlooking Kristiansand in Norway. Notice the large amount of overlap between adjacent shots.

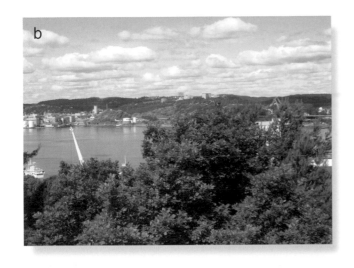

Figure 9-40: All six images are imported into Canon's PhotoStitch software.

Figure 9-41: The software merges them all together.

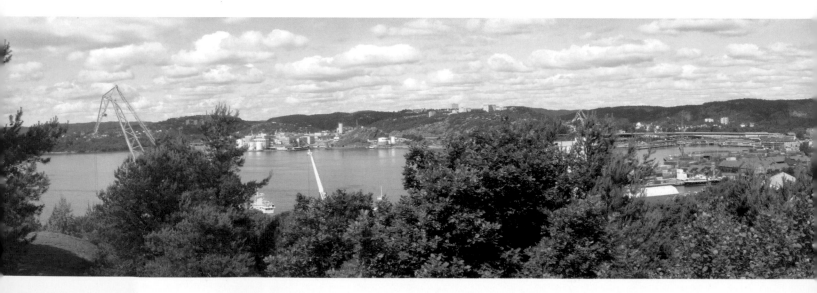

Figure 9-43: An example of more advanced image editing. The same boy appears four times in the image.

Figure 9-42: The jagged edges are dressed to produce a clean, rectangular image of the entire panorama.

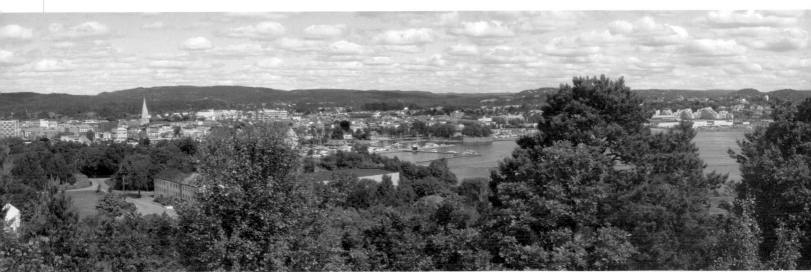

Creating a slideshow

Creating a slideshow from your images is made simple by the specialised software now available. Packages such as CyberLink's Medi@Show, which is often distributed free with new computers or at reduced rates on magazine disks, are easy to use. You nominate a filename for the show, select and import the images you want to include, and decide if you want them to change automatically, or at the click of your mouse.

Once the images are chosen you can alter the timings and transition effects (fading, and so on). By clicking a few buttons and choosing from the choices displayed. You can also add border masks (see figure 9-44), title text and background music.

Finally, you can export your show to enable it to be played on any computer – even one without the Medi@Show software installed – or in a form ready for uploading to the Internet. You can even create screensavers from your shows.

Figure 9-44: Adding a border mask to an image in a slideshow using Cyberlink's Medi@Show software.

Image filing

Large numbers of image files can accumulate in a surprisingly short time. Unless you are disciplined about the way in which you store them, you can very quickly lose control; the task of backtracking and sorting out hundreds of old images is daunting. Remember, an image you can't find is of no use to you. A few simple guidelines will help you to manage your collection.

Don't waste valuable disk space on your failures. Any images that are not worth keeping, or any surplus of similar shots, should be deleted promptly. However, the cost of burning a CD-ROM is low so, if there is any chance you might need to use an image in the future, archive it onto disk.

Image information should be recorded routinely after each batch of photographs, and you should archive your images regularly. Don't leave these tasks for too long or they will never happen. Always store images using a logical folder structure and always use meaningful filenames.

Figure 9-45: The File Info dialog in Photoshop.

Some software supports the storage of file information (see figure 9-45). This may include information about the photographer, keywords, archive categories and the EXIF data (data stored by the camera about the settings that were used when the picture was taken). For example, in Photoshop this information can be accessed by selecting File Info from the File menu. If possible, complete the fields and use this as a means of storing information within the image file.

You could simply store the image files in a Windows folder structure and then use a database to store the associated information separately. This simple approach has the advantage of incorporating data about images archived to CD-ROM and a field to tell you on what number CD the image you require is stored. The disadvantage is that unless you create and store thumbnails in your database, you are searching by description. As an alternative, purpose-designed image-management software can be used. Some packages store the images and file information (date, keywords, and so on) separately, while others access the embedded image data. Some even incorporate image-editing facilities.

It all depends on how many images you want to archive and what data you need to store in order to help you retrieve them again. A serious photographer would need to use keywords to find a specific image, but merely storing the pictures in an album would suffice for most people's holiday snaps. Incidentally, as well as conventional hard copy albums, you might consider the software equivalent or both.

managing your images

- Don't waste disk space on your failures: delete images that are not worth keeping.

- If you take several similar shots, only keep the best one or two.

- The cost of burning a CD is low so, if there is any chance you might need to use an image in the future, archive it onto disk.

- Record image information routinely after each batch of photographs; don't leave the task for too long.

- Archive your images regularly.

- If you are not using special file management software, make sure you create a logical folder structure and use meaningful filenames.

- If your software supports the storage of file information (for example, keywords and archive categories), complete the fields and store your information within the image file.

Chapter 10:

Using your Images

Having taken your photographs and, if necessary, edited your images, what can you do with them? The obvious action is to print them, but there are other possibilities to consider. Among them are digital projection, getting your images made into gifts (and not just as pictures in frames), and very importantly these days, using Internet-based applications.

Printing

You may decide to have your images printed professionally, but it is more likely that you will want to print the pictures yourself at home. If you want especially high-quality, or very large prints, you can take your image files to a processing laboratory. Most places will accept image files in any of the common file formats, and on a variety of media types (memory card or CD-ROM, for example), and many will download them direct from your camera. You can even send the images electronically to some Internet-based companies, pay by credit card and wait for them to post the prints to you.

Some cameras can simplify the printing process by using the Digital Print Order format (DPOF) which stores information defining how many copies of specific images on a memory card are to be printed, together with other related data. The inputting of the information is via one of the

Figure 11-01: Epson's Stylus CX6600 multifunction printer and scanner.

camera's menus and usually consists of text files stored in a special directory on the card. The memory card can then be printed via a compatible printer, or at a print shop or laboratory.

Printers for home use start from well under £50 and although some of the cheapest models do give poor picture quality, many reasonably priced printers give superb results. Within a manufacturer's range, the increased cost is often associated not with image quality, but with speed, robustness and the provision of additional features. As the models are updated continually, you'll need to refer to a recent review in a photographic or computer magazine to see what is currently offering the best value for your money.

Inkjet printers are by far the most common choice. They offer good quality at a reasonable price. Inks will fade if exposed to bright light for long periods, but they are more stable than they used to be. Other alternatives include thermal-dye printers and laser printers. Although still much more expensive than inkjets, the latter have fallen in price in recent years, with colour laser printers now starting to become affordable. Thermal-dye (or dye-sublimation) printers transfer each colour in turn from a dye roll, then a clear protective layer is added, making the prints quite durable. However, the cost per print tends to be expensive.

Figure 10-02: Lexmark's Z815 inkjet printer prints both colour documents and photographs.

Most inkjet or laser printers can handle any paper size up to a maximum of A4 size (29.7 x 21.6cm 11 x 8⅓in). Inkjet printers that can print on larger-sized paper are available, but tend to be much more expensive. Most amateur photographers use an A4 printer, with anything larger being printed professionally. Thermal-dye printers often have a smaller print size, typically 15 x 10cm (6 x 4 inches).

Figure 10-03: Thermal dye sublimation printers use four-colour transfer rolls like this one made by Xerox.

Figure 10-04: Previously extremely expensive, colour laser printers like this Konica Minolta magicolor 2440w are becoming much more affordable.

Resolution

Printer specifications usually state a maximum resolution value quoted in dots per inch (dpi). The higher the resolution, the better the image quality should be. It should be noted, that because of the way different technologies work, it is not possible to compare the resolution value of different types of printer directly. For example an inkjet printer of 1200 x 4800dpi is roughly equivalent to a thermal dye printer of 300 x 300dpi. Similarly because of the number of ink dots used to give a single pixel its correct colour shade, a 4800dpi inkjet printer does not print at anything like 4800 pixels per inch (ppi).

What resolution does your image need to be? As a general guide for inkjet printing, you would be well advised to base your image size on 300ppi – this gives a photo quality above which the human eye cannot detect improvement – although a figure of around 215ppi would suffice for most home purposes. This can be reduced for draft quality printing and may be increased for very high-quality professional work.

For example, if you have a 4 megapixel (MP) camera and want to produce a 18 x 13cm (7 x 5in) photo-quality print

Required image resolution = print size x print resolution

= (7 x 300) by (5 x 300)

= 2,100 by 1,500 pixels

This would be no problem for a typical 4MP camera. However, if you wanted to make a 25 x 20cm (10 x 8in) enlargement, to use the same print resolution you would need a much more expensive 8MP camera see table on page 31. However, if you were prepared to accept a lower print resolution, say 215ppi, then re-working the calculation gives:

Required image resolution = print size x print resolution

= (10 x 215) by (8 x 215)

= 2,150 by 1,720 pixels

Remember that this is the size of the image you want to print, which may only be part of a larger image. If you intend to crop your image using editing software, or if you intend to have it printed by a print laboratory you would be wise to add a margin of, say, 30 per cent to the calculated size.

Printing without a computer

You can still print your photographs even if you don't have a computer. However, you will need to make sure you use a printer that incorporates a card reader so you can plug your camera's memory card into it, or a printer that can connect directly to your camera. If both your camera and printer conform to the PictBridge standard you can be assured that they are fully compatible.

Figure 10-05: The FujiFilm Printpix CX550 Photo Printer is Pictbridge compatible, so can be connected directly to a camera.

Figure 10-06: The Hewlett Packard PhotoSmart 325 dedicated photo-printer. Notice the memory card slots that allow direct printing.

Paper and ink

If, as most people do, you choose an inkjet printer, you will need to decide what paper to use with it. This is a very important consideration; ordinary white copier paper tends to be slightly absorbent and is unsatisfactory. Although more expensive, special photo papers give dramatically better results. These come in several finishes (typically matte, semi-gloss or satin, and high gloss) and a range of weights (typically 150 to 300gsm). For comparison, photocopying paper is usually in the range 80 to 100gsm and copier card is around 160gsm. Do remember that the most expensive paper may not be the best for your particular printer and ink. In one recent review of matte papers, the cheapest paper tested scored 79 percent; whereas a paper costing more than 12 times as much scored only 51 percent (the highest score of any paper in the test was 86 percent). Try to obtain a range of samples and experiment to see what suits you best. Always store your paper properly, keep it flat, away from sunlight, heat or damp, and hold it by the edges – avoid handling the surface to be printed.

Figure 10·07: Good quality paper is essential for good quality printing.

As well as paper, you need to choose your ink. Printer manufacturers are very keen for you to buy their own brand of ink and the generally accepted view is that they are the best in terms of picture quality and long-term stability. However, they tend to be very expensive and the much cheaper compatible ink cartridges or refills are therefore very popular. Again, you must make your own choice as to what is best for you. Be warned, however, that using compatible ink cartridges during your printer's warranty period may cause you problems if you need to make a warranty claim.

Although no guarantee of high-quality output, the greater the number of different coloured ink cartridges in a printer, the better the printer should be able to reproduce subtle shades and tones. This is particularly important for skin tones. Some printers use separate ink cartridges for each colour; others – particularly the cheaper ones – combine as many as three colours in a single cartridge. Combined cartridges usually have a lower capacity and can be wasteful, as the remaining ink in the other compartments must be discarded when one colour becomes empty. Printers that do not use a separate black ink cartridge produce a composite black colour by mixing the other colours. This sometimes produces a shade that is not true black, but has a definite colour tint. These printers should be avoided if you intend to print monochrome images.

Figure 10-08: Although more expensive, printer manufacturers' inks are generally considered superior to the cheaper alternatives.

Maintenance and calibration

Figures 10-09: Making a printer test page. When it is printed, the coloured blocks are checked carefully to ensure all the shades are printed correctly.

Printer maintenance is important. Apart from changing print cartridges when they become empty, to get the best-quality images you need to ensure that the cartridges are clean and are correctly aligned. Generally, this should not be a problem, but if your printer is not in regular use, ink may dry on the print heads and clog the tiny nozzles. This causes a significant loss of print quality. If your image shows an offsetting between different colours then your cartridges are probably out of alignment. One way this can happen is if your printer has been jolted during transport. Both of these problems can usually be corrected using a set-up routine incorporated in the software supplied with your printer. Consult your printer's manual for full instructions.

Figure 10-10: Hewlett Packard's printer calibration screen.

Just as you need to calibrate your monitor to ensure a consistent display, you must calibrate your printer to ensure it prints correctly. You need to consult your printer's handbook for detailed instructions, but typically you can print a test image (there are some good ones available for download from the Internet, or you can create your own from within your graphics software) and then tweak the settings until all the shades of all the colours print correctly. Alternatively, if your printer supports it, you can use ICC (International Colour Consortium) profiles; these are pre-defined profiles that characterise specific printer/ink/paper combinations.

Things to consider when buying a printer

Q: What type of printer should I buy?

A: Inkjet printers are the most common. They offer good quality at a reasonable price. Other alternatives include thermal-dye printers and laser printers. Although still much more expensive than inkjets, the latter have fallen in price in recent years, with colour laser printers now starting to become affordable.

Q: What paper size can I use?

A: Most inkjet or laser printers can take a variety of paper sizes up to a maximum of A4 size. Although inkjet printers that can print on larger sized paper are available, most photographers are happy with an A4 printer.

Q: Does the printer have a paper tray?

A: Printers may be single sheet feed (where you put paper in one sheet at a time), have a shelf arrangement that carries a small stack of paper, or have an enclosed paper tray. The latter offers the greatest convenience for high-volume printing.

Q: What is the maximum weight of paper that can be used?

A: Because photo papers tend to be quite heavy (200–300gsm), your printer must not have any tight turns in the paper path. The heaviest paper allowed will be listed in the printer's specification.

Q: How many ink cartridges are there?

A: Printers with more colour cartridges should be better able to print subtle shades. Printers with composite cartridges containing up to three coloured inks tend to be cheaper, but are wasteful of ink. If you intend to print monochrome pictures make sure your printer contains a black ink cartridge.

Q: What is the maximum resolution of the printer?

A: The higher the resolution (usually expressed in dpi) the better the image quality should be.

cont'd

Q: What is the print speed of the printer?

A: If you are intending to print large numbers of images, you should consider buying a printer with a high print speed, usually expressed in terms of pages per minute (ppm). Faster printers are usually more expensive.

Q: Can I connect my camera or memory card directly to the printer?

A: Without a computer, you will need to make sure your printer can either connect directly to your camera, or has a card reader that is compatible with your camera's memory card.

Q: Can I print borderless pictures?

A: You might consider whether you want to be able to print right to the edge of the paper, or if you are happy to leave a plain border around the edge of the paper.

Q: What will be the cost per print?

A: The actual cost depends on your choice of paper, ink and print-quality settings. Some comparative reviews of different printer models give indicative cost data. As these should be based on the same basic parameters, they give an indication of relative costs irrespective of your chosen consumables. Be aware that some manufacturers keep the cost of printers low to encourage you to purchase them, and then make their profits by charging very high prices for consumables.

Showing your images to groups of people

Prints are fine to show to one or two people at a time, but there are occasions on which you might want to show your images to a larger number of people. In conventional photography this would have meant putting transparency film in your camera and projecting the resulting slides in a darkened room onto a screen using a slide projector. Projecting slides worked well for people giving talks to societies, and so on, but it was cumbersome for smaller groups, such as a family gathering. Once again, digital photography has revolutionised the giving of slide shows.

You can put your images onto CD-ROMs or DVDs and display them via a DVD player onto your television set. This is ideal for showing your pictures to small groups in your home.

Inexpensive software can be used to aid this process, including the addition of backgrounds, commentary and music, as well as interactive menus and timed image changes.

Figure 10-11: Hewlett Packard's SB21 digital projector.

If you intend to give talks, or show your pictures to large groups, you can use a digital projector and a screen. Although similar to slide projection, there are a number of advantages (see table below). You should remember that, although some projectors have on-board memory capability, you will often need to have a laptop or DVD player to transfer the images to the projector during your presentation.

Generally, a digital projector will be much closer to the screen than a conventional projector. This means the image is projected upwards at quite a steep angle. If a conventional projector were used in this way the image would distort and become trapezoidal, with the top edge being longer than the bottom. Digital projectors can compensate and correct for this by using software to distort the image in the opposite way.

Figure 10-12: This picture of Ballachulish bridge is suffering from the keystone effect of being projected steeply upwards without the benefit of auto-correction that is built into many digital projectors.

The pros and cons of digital projection

Pros

Versatility:
The same image can be used more than once in the same or a different presentation.

Security:
You can keep a copy of your images in a safe place – with slides you generally project from your original transparency.

Image correction:
Many digital projectors allow you to adjust brightness and contrast, and importantly, to make keystone correction.

Multimedia:
Coordinated soundtracks can easily be added to your presentation.

Cons

Initial cost:
The cost of digital projectors has fallen dramatically, but they are still more expensive than slide projectors.

Running costs:
When buying a digital projector, ask about lamp life and the cost of replacement bulbs. In some cases these can be incredibly expensive.

Image quality:
The image quality from digital projectors can vary considerably, particularly at high magnifications. Consider the largest screen you will be using when you buy a projector.

Additional equipment:
Although you won't need to carry boxes of slides, you will usually need a portable computer or DVD player.

E-mail, online photo albums and websites

For those photographers with access to the Internet, it can provide an extremely useful way of enabling people to see your pictures. If you have family or friends who live abroad – or who live in this country, but who cannot attend a special occasion – you can send copies of your digital pictures to them via e-mail. This can be very rapid: your relative could receive a picture of a birthday party while it was still in progress, for example.

Another alternative is to put your pictures into an online photo album. Hosting companies offer these as a user-friendly way for you to put pictures onto the Internet. The cost of using online albums varies: some charge an annual fee, others are free. The free ones may have limitations, such as the number of pictures you can post, or the length of time the images will be displayed. They make their money either through the use of advertising on the album pages or by offering to sell prints of your pictures. Remember that if you use a free service you have no contractual agreement with the host company – if they take your pictures off-line there is nothing you can do about it. Online albums should not be considered a method of archiving your pictures. Always keep a copy of the files yourself in case the host company ceases trading.

The following on-screen browser content is part of the figure:

THE TEESSIDE BRANCH PHOTO GALLERY

Pictures of Member's Greenhouses

The following pictures show a selection of the collections of some of our members (past and present). It should be noted that these pictures are by no means representative of all of our member's collections, member's with a few plants on a windowsill are just as valued as those who have large numbers of specimen plants.

Figure 10-13: Taking digital pictures means you can quickly add photographs to your own website or to one for a society with which you are involved.

Many Internet Service Providers (ISPs) provide a quantity of free web space as part of their standard package. If yours does, and if you are so inclined, you could consider building your own website. Although it takes more effort than uploading pictures to an online album, it is not as difficult as you might think and you get control over the layout and appearance of the pages.

Figure 10-14: No matter how cute your pet, your friends won't thank you if you e-mail them a huge 25MB uncompressed file attachment.

Whichever Internet-based method you choose, you must take care selecting the file format and image size. Even if they have a broadband connection, your friends will not thank you for sending them a 25MB file containing a snapshot of your favourite pet. Similarly, no one will have the patience to wait while your website loads if it contains very large pictures. Most computer screens will have a resolution of 1024 x 768, or 800 x 600. Unless you expect the recipient of an image to want to zoom in to see just part of it, or to print it at a large size, there is no point in using an image larger than this. Re-sizing a picture

can reduce the file size dramatically. Use a JPEG file format – the standard for pictures on the Internet and set it to a moderate amount of compression. There will be a small amount of quality loss, but this will usually be negligible and the file size will be reduced.

Ideally, images for websites should not have a file size greater than about 70KB, and preferably less than 50KB. If you have a good reason to use larger images, put each one on its own separate page. You can then put small versions of them all – usually referred to as thumbnails – on your main page with links to the larger files.

Figure 10-15: Sending digital images via e-mail allows absent members of the family to stay in touch. They can even see pictures of special occasions while they are in progress.

Other uses for your images

The use of traditional photographs was more or less limited to prints or projected slides. Today, there are many other things that you can do with your digital image files. For example, if you become skilled at the use of a computer you can easily produce your own greetings cards and calendars, or maybe a newsletter.

For more unusual uses you will probably need to take your images to a specialist dealer, or send them to one online. You may be surprised how quick and – given that these are customised items – inexpensive these services can be. The range of available products includes the following:

- **Fabric items:** T-shirts, cushions, bags
- **Useful items:** Mugs, placemats, coasters, mousemats
- **Gifts:** Jigsaws, laser-engraved glass key rings, paperweights, even chocolates
- **Stationery:** Stickers, postcards

Figure 10-16: Digital images can be printed onto a wide range of products.

It is possible to print your own transfers and apply them to blank shirts, mugs, and so on, but although you would save money compared with getting them done professionally, you may find the results are not as good and do not last as long.

Glossary

The following list of definitions is provided as an aid to understanding the more commonly used technical terms associated with digital photography.

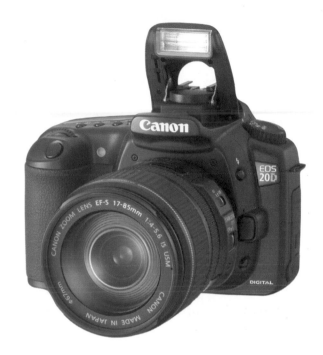

24-bit colour: *A palette of over 16.7 million colour shades; also known as TrueColour.*

35mm: *A conventional film system with a 3.6 x 2.4cm frame size.*

A3: *A standard metric paper size, used throughout Europe, it is 42 x 29.7cm.*

A4: *A standard metric paper size, used throughout Europe, it is 29.7 x 21cm.*

Actual pixels: *The number of pixels in a sensor array. Also known as total pixels.*

Advanced Photo System: *A conventional film system with a 1.67 x 3.02cm frame size. It is preferred to 35mm by some people due to its ease of use.*

Aperture: *The size of the lens opening. A large opening allows more light to pass, but results in a smaller depth of field.*

APS: *See "Advanced Photo System".*

Aspect ratio: *The relative proportions of an image (e.g. an image with an aspect ratio of 0.75 would have side lengths in the proportion of 4:3).*

BMP or Bitmap: *The Windows Bitmap image file format, it is a lossless format for saving image files.*

Bounce flash: *Tilting a flashgun so that, instead of pointing directly at the subject, the light is bounced off another surface – usually the ceiling.*

Bracketing: *Taking more than one shot of the same image at different exposure and/or white balance settings.*

Brightness: *The level of light intensity of an image.*

Bulb setting: *A camera's manual setting where the shutter opens when you press the shutter button and remains open until you release it.*

Burst mode: *A camera mode that allows for the continuous shooting of multiple images.*

CCD: *An abbreviation for Charge-Coupled Device. A type of sensor array.*

CD-ROM: *An abbreviation for Compact Disk – Read Only Memory. Computer files, including photographic images, can be archived onto writable or re-writable CD-ROMs.*

Cloning: *The duplication of areas of an image.*

CMOS: *An abbreviation for Complimentary Metal-Oxide Semiconductor. A type of sensor array.*

Colour model: *The base colours used to define all other colours. Usually red, green and blue (RGB) or cyan, yellow and magenta (CYMK). It is sometimes referred to as colour space.*

Colour space: *See colour model.*

Colour temperature: *The measurement of colour bias of a light source. It is measured in degrees Kelvin (K).*

Compact camera: *A small size, self contained camera, typically with built-in zoom lens and flash.*

Compositing: *The creation of an image from two or more other images.*

Contrast: *The range of tones between the brightest and darkest areas of an image.*

CPU: *An abbreviation for a computer's central processing unit.*

Cropping: *Reducing the size of an image by cutting away unwanted areas.*

CRT: *An abbreviation for cathode ray tube, a type of computer monitor.*

CYMK: *The cyan, yellow and magenta colour model. It is often preferred to the more usual RGB model by professional printers. The K refers to the addition of black in the printing process.*

Depth of field: *The region of a photograph within which the image is in sharp focus.*

dpi: *The measurement of a printer or scanner's resolution, it is an abbreviation for dots per inch.*

DPOF: *The Digital Print Order Format stores information that defines the printing requirements for images on a memory card.*

DVD: *An abbreviation for Digital Versatile Disk (sometimes incorrectly called Digital Video Disk). Computer files, including photographic images, can be archived onto writable or re-writable DVDs.*

Effective pixels: *The number of pixels actually used to produce an image (usually less than the actual number of sensor pixels, but can be more than if the camera employs interpolation).*

EV: *An abbreviation for Exposure Value. It is used with a number (e.g. +2EV) to indicate the amount of an over or under-exposure compensation setting.*

EXIF: *The Exchangeable Image File format is used by many digital cameras to store information such as the date/time and the camera settings when an image was taken.*

Exposure: *The total amount of light reaching the camera's sensor array. The actual amount of light is a function of shutter speed and aperture.*

File format: *The way in which the image information is stored within the data file. Different file formats are distinguished from each other by an extension to their name (e.g. .jpg or .psd).*

Fill-in flash: *The use of a flashgun in bright conditions to remove a shadowed area from the subject of a photograph.*

Film speed: *The sensitivity of film to light, measured as an ISO number.*

FireWire: *A high-speed data connection between a camera or scanner and a computer. Also known as IEEE 1394.*

Focal length: *The figure in millimetres that defines the angle-of-view of a lens.*

Foveon®: *A multi-layered sensor array technology.*

f-stop: *The aperture of a camera lens is measured in stops or f-stops. The larger the number (e.g. f4) the smaller the lens opening and the less light that is allowed through.*

Gamma: *Gamma adjustment is a method of tonal correction that shows detail in a low-contrast image without significantly affecting the shadows or highlights.*

Gamut: *The range of colours a device can produce.*

GIF: *The Graphics Interchange Format is an image file format that is limited to 256 colours. GIF files are small in size and are ideally suited for internet clipart, but they are unsuitable for most digital photography.*

gsm: *The measurement of the weight of paper, it is an abbreviation for grams per square metre.*

Hot shoe: *A bracket with electrical contacts used to connect a flashgun to a camera.*

ICC: *International Colour Consortium, referred to in the context of colour profiles for printer calibration. These are pre-defined profiles that characterise specific printer/ink/paper combinations.*

Kelvin: *The temperature scale used to measure colour temperature. It is abbreviated to K.*

LCD: *An abbreviation for liquid crystal display.*

Internet Service Provider: *A company supplying a connection service to the internet.*

Interpolation: *The use of mathematical techniques to provide data for an increased number of pixels.*

ISO: *An abbreviation for the International Standards Organisation. The abbreviation is usually seen in conjunction with a number to designate film speed, or the digital equivalent, the sensitivity of the sensor array.*

ISP: *See Internet Service Provider.*

JPEG or JPG: *An image file format named after the Joint Photographic Experts Group. It is a lossy format. Because of its good compression properties, JPEG is the standard image format for use on web sites and by many cameras.*

Keystone correction: *When an image is projected on a plane that is not perpendicular to the projection screen the image will be distorted. This is called the keystone effect and can be corrected by the software in digital projectors.*

Lossless: *A term used to describe file formats in which the image quality is not degraded.*

Lossy: *A term used to describe file formats in which the image is compressed at the expense of a loss of quality.*

LZW: *A compression system sometimes used to reduce the size of TIFF files.*

Matrix-metering: *An evaluative form of light metering employed by many cameras.*

MB: *See Megabyte'.*

Megabyte: *A unit for measuring the size of a computer file. One megabyte is 1024 kilobytes.*

Monochrome: *An image made up of black, white and shades of grey.*

Native File Format: *A hardware or software manufacturer-specific file format.*

Noise: *Coloured speckles visible in dark areas of an image, particularly when taken in low light using high ISO speed settings.*

OCR: *An abbreviation for Optical Character Recognition. It is software that converts a scanned image of a document into editable text.*

Panning: *Moving the camera to follow a fast moving object.*

PCT or PICT: *The Macintosh Picture image file format.*

PictBridge: *An interface standard to ensure compatibility between cameras and printers.*

Pixel: *One of many coloured dots that together make up an image. It is an abbreviation for picture element.*

Plug-ins: *Small pieces of add-in software that give extra functionality to a software package.*

PNG: *The Portable Network Graphics image file format is a relatively new lossless format intended to be used for the internet.*

ppi: *The measurement of an image's resolution, it is an abbreviation for pixels per inch.*

ppm: *The measurement of a printer's speed, it is an abbreviation for pages per minute.*

PSD: *The native image file format used by Adobe Photoshop.*

PSP: *The native image file format used by Paint Shop Pro.*

RAM: *The memory in your computer. Image editing requires large amounts of memory. RAM is an abbreviation for random access memory.*

RAW: *A file format that produces images that are not processed within the camera. It is a lossless format.*

Red-eye: *The effect of a flash being reflected in the subject's eyes turning them red.*

RGB: *The red, green and blue colour model.*

Ring flash: *A annular flashgun that mounts on the front of a camera lens. The picture is taken through the hole in the middle. It is used for macro (close-up) work.*

SCSI: *A high speed data connection sometimes used to connect a scanner and a computer. It is an abbreviation for Small Computer Serial Interface.*

Shutter Speed: *The length of time during which light is allowed to pass through the lens onto the sensor array.*

Slave flash: *A secondary flash unit triggered by one mounted on or connected to the camera.*

SLR: *An abbreviation for Single Lens Reflex Camera. A mirror arrangement allows the interchangeable lens to provide both the image on the film (or sensor array) and the image seen in the viewfinder.*

Software: *A piece of programming in a computer or other microchip device (including a digital camera).*

Spot-metering: *A method of light metering where a light reading is taken from a specific localised area in the image.*

sRGB: *A variation of the RGB colour model. It has a smaller gamut – or range of colours – and is designed to provide better matching between on-screen and printed images.*

Stop: *See f-stop.*

Telephoto: *A lens with a long focal length. It makes the subject appear closer to the camera.*

TFT: *An abbreviation for thin film transistor, a type of computer monitor that uses a liquid crystal display.*

TIF or TIFF: *Tagged Image File Format , a lossless image file format. Files tend to be large in size.*

Time-lapse photography: *The taking of a series of images at regular time intervals to show change occurring.*

TrueColour: *A palette of over 16.7 million colour shades also known as 24-bit colour.*

TWAIN: *The interface standard for data transfer between a scanner or digital camera and image processing software. It is not an abbreviation.*

USB: *A data connection used to connect items such as a keyboard, mouse, printer, camera or scanner to a computer. It is an abbreviation for Universal Serial Bus. USB 2.0 provides much higher speed data transfer than the older USB 1.1 standard.*

White balance: *Adjusting the camera (or editing software) to compensate for the colour cast caused by a light source, in order to make white objects appear truly white.*

Wide-angle: *A lens with a short focal length. It makes the subject appear further away from the camera.*

Zoom: *A lens with a variable focal length.*

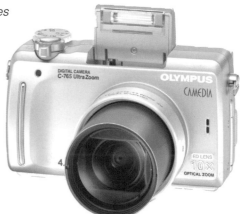

Index

Credits and Acknowledgements

Grateful thanks go to those who helped make this book possible:-

My father for first giving me the interest in photography, and for his help, advice and encouragement over the years.

My wife Ann for supporting me and allowing me to indulge in photography, as well as my other hobbies and interests.

John Nicholson for his assistance with proofreading and the checking of the data included in this book. However, it must be stressed that any errors that may remain are my responsibility not his.

Kath Atkinson for her assistance and for allowing me to include her composite picture on page 203.

Derek MacDonald for providing the picture of his son.

All the people who appear in my pictures in this book, in particular Karen Wharton.

David King for giving me the opportunity to write this book.

The author and publisher are grateful to the following companies which supplied images or granted permission to illustrate their software or websites:

- Adobe
- Canon
- Corel
- Cyberlink
- Hewlett Packard
- JASC
- Jessops
- Microsoft
- Nikon
- www.photobox.co.uk